Learn to Draw

DOGS

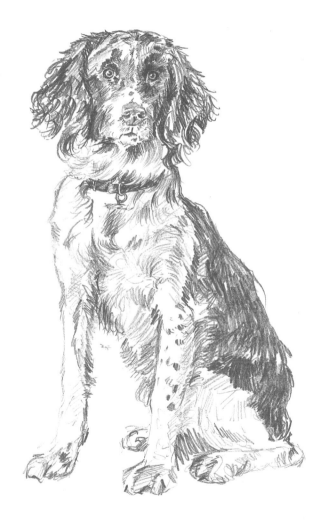

David Brown

HarperCollinsPublishers

First published in 1996
by HarperCollins Publishers
London

© HarperCollins Publishers 1996

Editor: Diana Craig
Art Director: Pedro Prá-Lopez, Kingfisher Design Services
DTP/Typesetting: Frances Prá-Lopez, Kingfisher Design Services
Contributing artist: Roger Hutchins

A catalogue record for this book is available from the British Library

ISBN 0 00 412789 7

Produced by HarperCollins Hong Kong

CONTENTS

Introduction

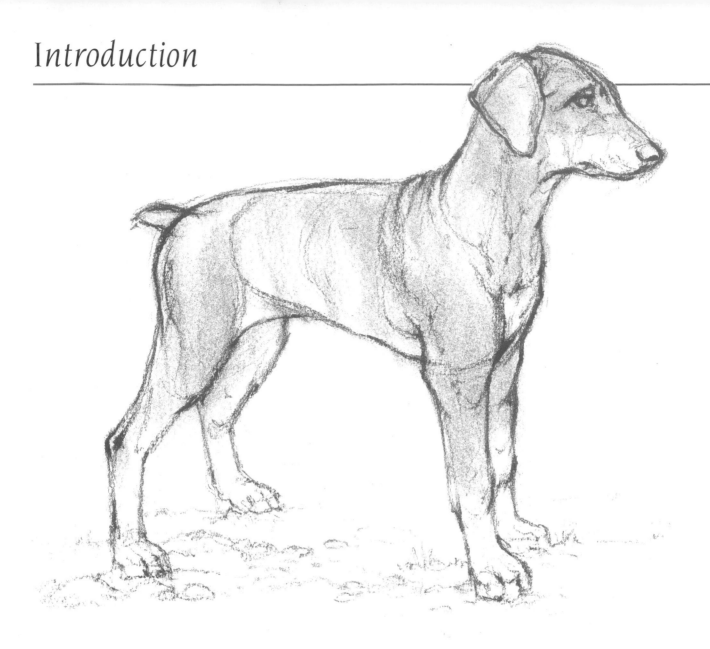

When I'm introduced to someone and they learn that I earn my living as a graphic artist, many of them say, 'It must be wonderful to be able to draw, I wish I could, but I'm hopeless.' When asked when they last attempted to draw, they usually admit that they never have! Others confess to drawing only as children in school.

Learning the mechanics
Being able to draw well is considered a gift, but that doesn't mean that one can't learn what I call the 'mechanics' of drawing, which form the basis of good draughtsmanship. By mechanics I mean learning how to observe your subject; knowing how to get the proportions right;

understanding the rules of perspective; coping with light and shade, and so on. This sounds pretty daunting, but by studying and practising the above one can derive a great deal of pleasure from producing an acceptable result, and in purchasing this book you have shown an interest and willingness to learn and so experience that pleasure.

When you are looking for your first subject, choose a dog with very short hair so that you can more easily see its shape. Initially, avoid dogs such as the Afghan Hound and Old English Sheepdog. These you can attempt when you have gained some experience and

knowledge of a dog's anatomy and form. To begin with, it would also be advisable to avoid dogs with unusual proportions, such as the Dachshund. Also avoid the temptation to draw only the head. There is nothing wrong with occasionally producing a head portrait, but don't continually do so; concentrate instead on studying the whole animal.

Approach with care

Dogs are generally extremely friendly animals, but caution must be applied when approaching one whose temperament you do not know. A well-trained dog is easy to control, making it an ideal subject for drawing. However, even an untrained dog will remain in one position for an appreciable time when comfortably sitting or lying down.

Practising to improve

The more often you practise drawing, the better your skills will be. Get into the habit of carrying a small sketchbook and drawing tools with you so that you are ready to take advantage of any opportunity to draw an interesting subject.

Remember, however, that you are not aiming for perfection every time. If you start out with the idea that you are going to produce a drawing good enough to frame, your work will be inhibited – you'll start to concentrate more on *how* you are drawing rather than on *what* you are drawing. Just enjoy what you are doing, and your skills will improve of their own accord.

D A Brown

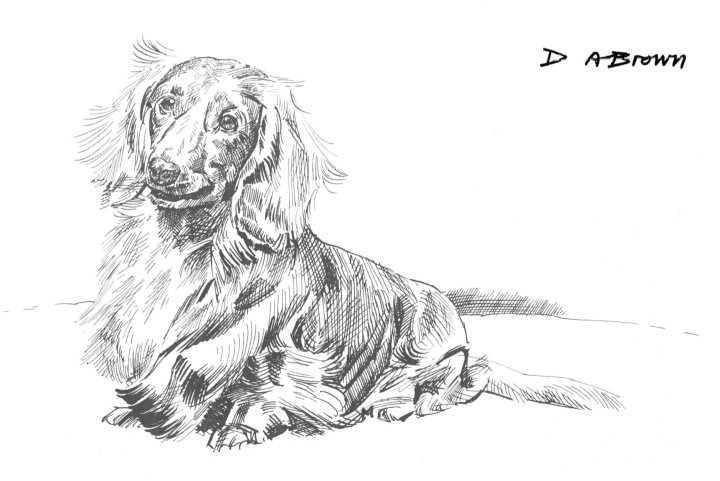

Tools and Equipment

When you begin drawing, choosing materials can be a bewildering task because there is such a wide range to choose from. The key factor to remember is always to buy the best materials you can afford – this won't guarantee to make you a better artist, but you won't be faced with such irritations as having to cope with inferior brushes that split into separate points, or gritty pencils that break. Start by buying whatever materials you feel most confident in using, and then add to your collection as your skills, enthusiasm – and pocket – allow.

Pencils

The inexpensive pencil is the most basic of drawing tools, but produces an enormous variety of line that ranges from thin and light to thick and dark, depending on the type of lead. In the middle of the range is the HB pencil; on either side of this the Bs become increasingly

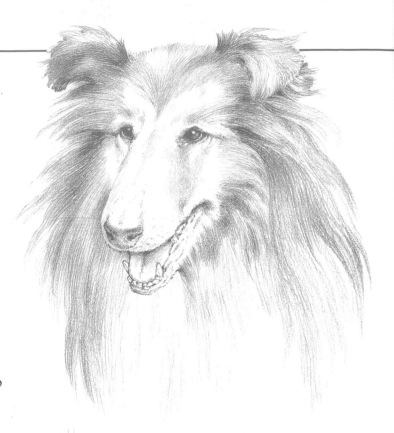

The medium-soft 6B pencil used to depict this Rough Collie on fine cartridge paper needed constant sharpening to produce the fine hairs of the dog's coat.

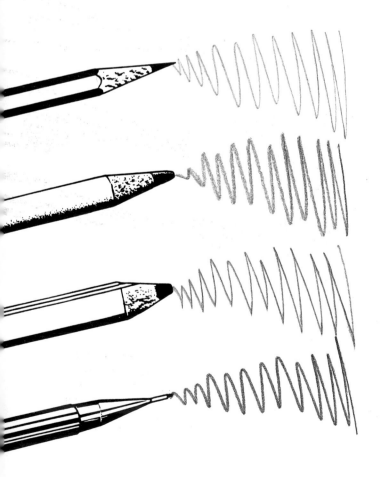

soft, and the Hs increasingly hard. The higher the figure, the harder or softer the pencil: for example, 2H is hard, 9H extremely hard, while 2B is soft, and 9B extremely soft.

When doing detailed work, keep sharpening your pencil so that it retains a fine point. The points of softer pencils wear down quickly when in use, so keep these sharpened, too. This way, the lead point will be well clear of the wood at the base, and the wood will not be able to scrape against your drawing and damage it.

Other varieties of pencil include the chisel-ended types. The leads of these have a broad, flat, chisel shape that makes a very thick line. There is also the wide range of coloured pencils, and it is fun to experiment with these. Try, for example, blending one colour into another to produce a third, or 'mix' the colour on the paper by building up a drawing with different-coloured dots or lines set close together, in the same way as the French artist, Georges Seurat.

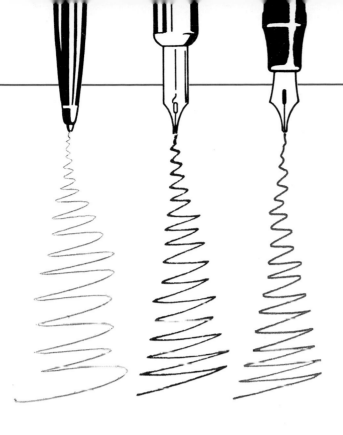

Fountain pens hold ink in a cartridge, so are ideal for taking out when sketching. Some have changeable heads to give different types of line.

Ballpoint pens are another very useful tool for sketching. Make sure you buy a smooth-running one or you may get a blotchy line.

Technical pens are ideal if you want a line of even thickness. They are numbered according to the line they produce: the lower the number, the finer the line.

Felt-tip pens are available in many colours and vary in thickness from fine to very broad.

Pens

As with pencils, the range of pens is enormous and new kinds are constantly being added. Here are some of the more common types.

Dip pens have been in use for hundreds of years. They consist of a holder containing a nib, which is then dipped into the ink. The nibs vary in thickness, the mapping pen giving probably the finest line. Try to buy nibs with the longest distance from the point to the 'shoulder', as these allow the greatest variety of line.

The solid black produced by felt-tip pen was perfect for the markings on these Dalmations. A fine felt-tip is also capable of making a delicate, sensitive line, as in the outlines here.

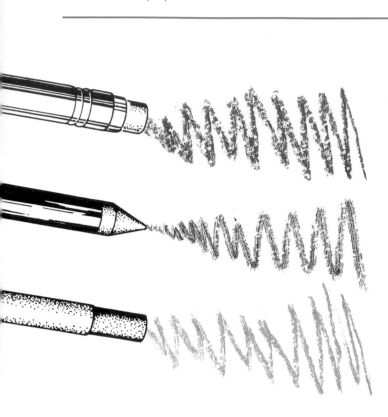

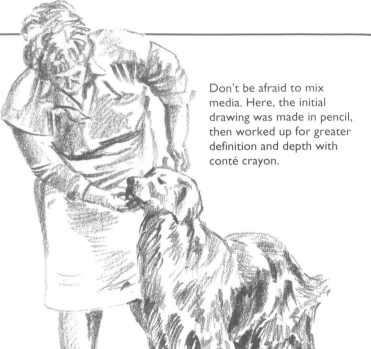

Don't be afraid to mix media. Here, the initial drawing was made in pencil, then worked up for greater definition and depth with conté crayon.

Pastels, crayons and charcoal
If you want a fine, precise effect, these very soft materials are not the ones to choose – but they are perfect for large, loose, textured drawings.

Pastels are available in an enormous range of colours, each having several *tints* (shades). Some manufacturers number their tints from 0 (the lightest) to 8 (the darkest). You can buy pastels in pencil or stick form. Pencils are harder and so are easier to sharpen. Both forms are sold in sets or individually. To begin with, it's best to buy a few singly to see how you like the medium. In this way, you'll also get to know the colours you use most, and you can build up your own set.

Oil pastels and wax crayons also come in a variety of colours. Because of their greasy consistency, they are difficult, if not impossible, to erase successfully once applied, so bear this in mind before you begin working with them.

Conté crayon is a similar medium to pastel, but has a slightly greasy texture that makes it harder and less crumbly.

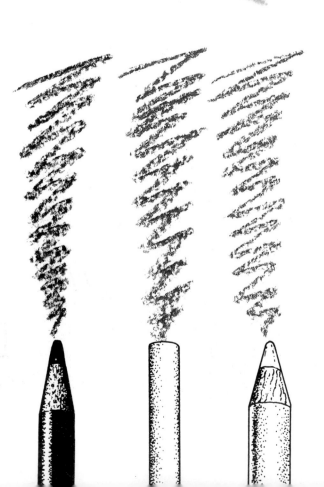

Charcoal is a traditional drawing medium, used by artists for centuries. It comes both in pencil and stick form. Pencils are cleaner to handle, but sticks encourage a bold, free style of drawing, ideal for larger-scale work or for 'loosening up' your style. You can produce broad strokes by breaking off a piece of the stick and applying it on its side (a method you can also use with pastel and conté crayon). To make finer lines, rub the tip of the charcoal on sandpaper to produce a point. Charcoal smudges very easily so avoid resting your hands on the drawing until it is properly fixed.

To pick out highlights and lighten areas in a pastel or charcoal drawing, gently dab the surface with a putty eraser. You can also blend colours by gently rubbing one into another with your fingers or cotton wool.

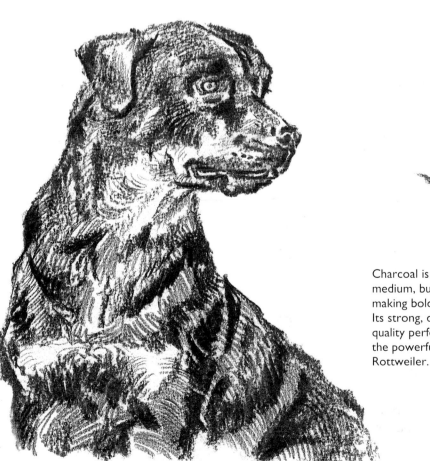

Charcoal is not a delicate medium, but is ideal for making bold statements. Its strong, densely black quality perfectly captures the powerful form of this Rottweiler.

Artist's Tip

Pastel, charcoal and other soft media need to be sprayed with fixative to prevent smudging. To store your work, slip tissue or similar paper between the pieces to separate them.

Brushes and wet media

The range of brushes is vast, not only in size and shape, but also in quality. Brushes may be round, pointed, chisel- or fan-shaped. The finer the point, the thinner the line a brush will produce. Broader, flatter brushes are best for filling in or laying washes.

Always buy the best-quality brush you can afford: it should be springy enough to revert back to its original shape after use. The best, longest-lasting – and most expensive – brushes are made of sable hair. Cheaper, but still good-quality brushes are those made of squirrel or ox hair, or synthetic fibres.

Inks may be applied with a pen to produce a line drawing, or diluted and brushed on as a wash. Alternatively, you can combine the two methods to produce a line and wash drawing.

3

5

4

6

3 For an even layer of strong watercolour, lay darker washes over a light wash while still wet.

4 To prevent colours 'bleeding' together, let the first layer dry before adding the next.

5 For a soft, smudgy effect, paint watercolour on to paper that has been slightly dampened.

6 Ink or concentrated watercolour on damp paper will spread into swirls and blotches.

I

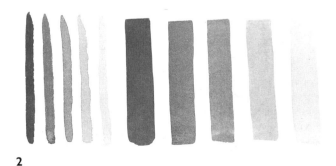

2

I These brush marks were made with (from left to right) a small, pointed brush; a flat brush; a large, pointed brush.

2 Watercolour tone can be progressively reduced by adding more water, as shown by these strokes using different dilutions.

To prevent the wash dissolving the line drawing, use waterproof ink for the latter and allow it to dry before applying the wash. A colour wash over black line adds yet another dimension. Inks are brilliant in colour and can be easily mixed.

Certain inks, particularly waterproof ones, can quickly damage a brush if it is not thoroughly washed immediately after use, so keep a medium-quality brush solely for ink work.

Watercolours are sold in tubes, small blocks called pans, or concentrated liquid form. They may be diluted with water to create subtle, transparent tones, or used straight from the container to produce strong, vivid colours.

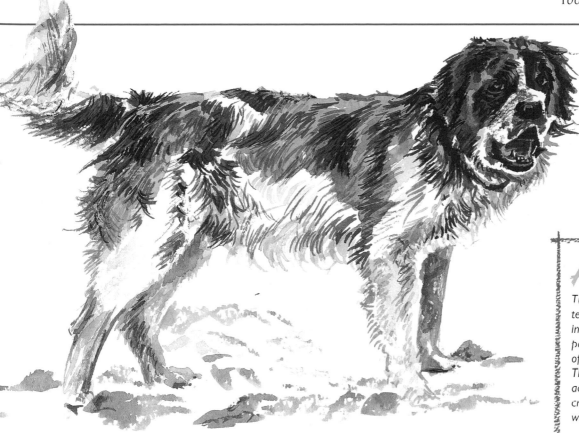

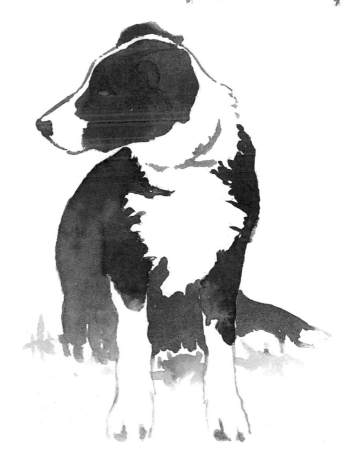

Artist's Tip

Try the wax resist technique. Do a drawing in wax crayon, then paint over it with a wash of watercolour or ink. The wash will not adhere to the greasy crayon, and the drawing will emerge through it.

A two-tone watercolour drawing of a Saint Bernard *(above)*. A darker tone defines the form and coat, while lighter washes create patches and shadows.

Sometimes simplest is best. The barest of painted outlines and blocks of watercolour wash create this delightful portrait of a young Collie *(right)*.

Gouache is a water-based paint. It can be diluted, like watercolour, to create areas of transparent colour, or used thickly to produce an opaque colour that is dense enough to obliterate any pencil drawing beneath it.

Acrylic paints are thick and resemble oil paint, but can be thinned by diluting with water.

Mixing colours

When using paints or inks, you will also need a jar of water for diluting colours and rinsing brushes, and a 'palette' for mixing colours, such as an old plate, or old bun tin with separate cups for holding individual colours. Test your new colour by dabbing it on a scrap of paper or the edge of your drawing. Change the water in your jar often so that it does not tint your colours.

Newsprint is very inexpensive, which makes it good for practising and rough sketching.

Tracing paper is semi-transparent, allowing you to see through and trace images that you like.

Stationery paper has a hard, smooth surface that suits the pen, but usually comes in only one size.

Cartridge paper is one of the most versatile of all surfaces. It usually has a slightly textured finish.

Surfaces to draw on

As well as the whole range of drawing tools, the choice of drawing surface is similarly wide – different papers and boards may be thick or thin, rough or smooth, white or coloured, and each will produce a different effect with your chosen medium. Although there are no hard-and-fast rules about which tool you use on which surface, some do not combine as well as others, so experiment with as many combinations as possible. For a wet medium, however, it's best to stick to board or heavy paper that won't buckle.

Papers vary in quality depending on whether they are made by hand, mould, or machine.

Handmade paper is made in individual sheets, so that each one is different from the next. This labour-intensive and time-consuming process creates an expensive but top-quality product.

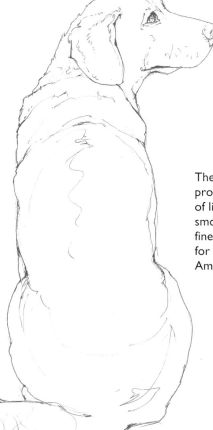

The ordinary ballpoint pen produces a great delicacy of line. It works best on a smooth surface such as the fine cartridge paper used for this drawing of an American Retriever.

Ingres paper, in various colours and with a lightly ridged surface, works well with pastel and charcoal.

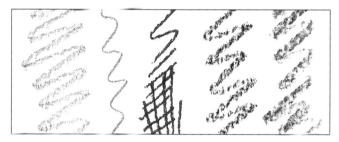

Watercolour paper is ideal for wet media, being thick and absorbent, with a rough surface.

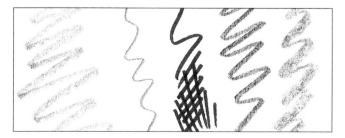

Bristol board is firm and has a smooth finish that makes it a very suitable surface for pen work.

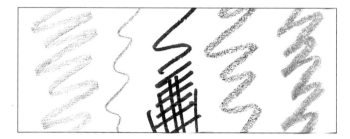

Layout paper is a semi-opaque, lightweight paper that is good either for pen or pencil drawings.

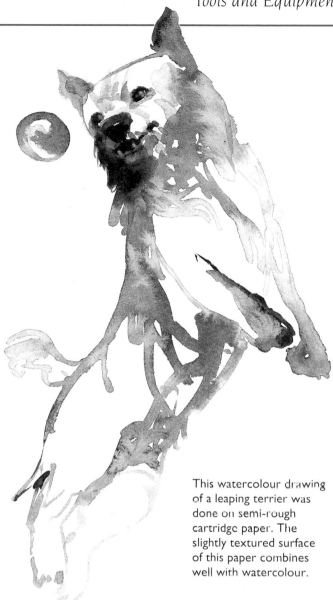

This watercolour drawing of a leaping terrier was done on semi-rough cartridge paper. The slightly textured surface of this paper combines well with watercolour.

Mould paper is also formed in individual sheets, but by machine, not hand. Paper made in this way has a right side and wrong side.

Machine-made paper is produced in a large roll of uniform quality. The roll is then cut into sheets which may be sold singly or bound into a pad. Machine-made papers are available in varying degrees of quality.

The surface of a paper depends on the finishing process. *Hot-pressed* paper is smooth, *not* (i.e. not hot-pressed) paper is slightly rough, and *rough* paper has a textured surface.

13

Choosing the Right Medium

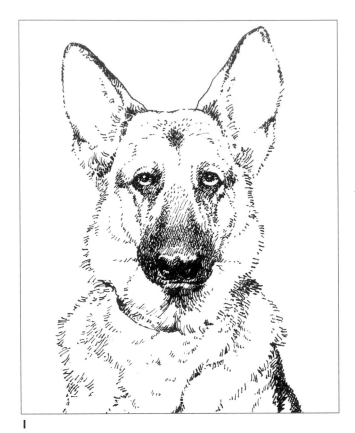

1

2

Of all the drawing tools available to the artist, the humble pencil is probably the most common and the most favoured. The popularity of the pencil is understandable. First of all, it is a very convenient tool, being light, small, and therefore easy to transport. Compared with charcoal, pastel, or pen and ink, it is much less messy to use – another reason that makes it more portable, for there are no risks of spills or smudges in transit. And finally, the pencil is cheap to buy and can easily be obtained in stationery and art shops.

Although the pencil has many advantages, it would be a great pity if you limited yourself to this medium alone and did not experiment with others. Only by experimenting with other media will you discover the kind of effect each produces. A time will come when you'll want to create a particular effect in your drawing and you will need to know which medium to choose.

However, it isn't your drawing tool alone that will produce a specific 'look'. The marks you put down on your drawing surface will be affected by the nature of that surface – whether it is rough or smooth, how absorbent it is, and so on. Experiment with different media on different surfaces to see how various combinations work.

In the pictures on these two pages, I have produced six drawings of the same dog. I am indebted to Chris and Shirley, two friends of mine, for allowing me to draw their dog Ria to illustrate how much her appearance changes with each change of medium and surface.

1 Dip pen and ink on smooth cartridge
2 Felt pen on medium cartridge
3 Watercolour on watercolour paper
4 Pastel pencil on grey Ingres paper
5 2B pencil on CS2 'not' paper
6 Charcoal pencil on watercolour paper

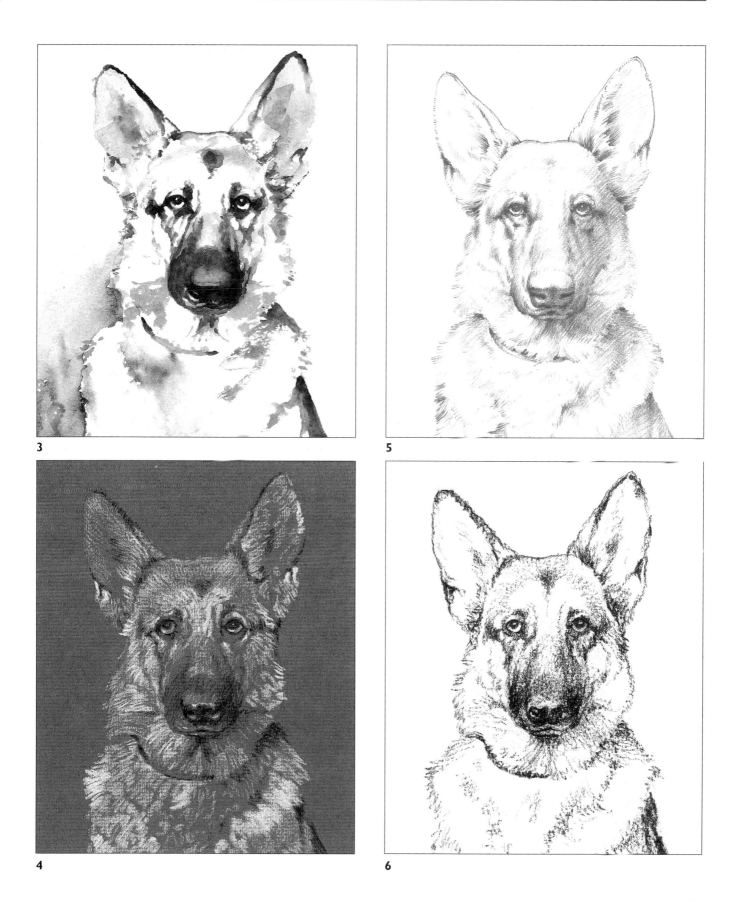

3

4

5

6

Proportion and Measuring

In order to produce good drawings of animals, whether of the farmyard variety or any other type, you need to master the basic elements of proportion – the sizes of the different parts in relation to each other.

For many people, this aspect of drawing presents one of the biggest problems. However, if you want your work to bear a convincing resemblance to the real thing, it is vital to get the proportions right. If the underlying structure is wrong, you will not be able to disguise the fact with shading or colour.

The pencil method

A simple but effective method of achieving this level of accuracy is illustrated below. Choose a portion of your subject – say, the head of the dog – and use this as your *measuring unit*. Hold your pencil at arm's length and line up the top of it with the top of the dog's head. Now place your thumb on the pencil to line it up with the bottom of the head. You now have a unit which you can use to measure how many head lengths make up the length of the body; by holding the pencil horizontally, you can also tell how many make up the width.

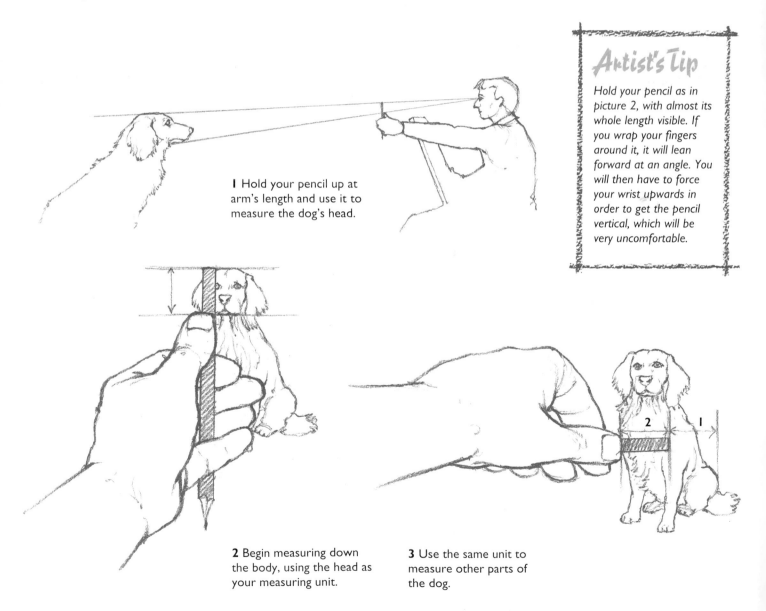

1 Hold your pencil up at arm's length and use it to measure the dog's head.

Artist's Tip

Hold your pencil as in picture 2, with almost its whole length visible. If you wrap your fingers around it, it will lean forward at an angle. You will then have to force your wrist upwards in order to get the pencil vertical, which will be very uncomfortable.

2 Begin measuring down the body, using the head as your measuring unit.

3 Use the same unit to measure other parts of the dog.

When measuring in this way, remember always to keep your arm straight, your pencil vertical, and your thumb on the same spot on the pencil.

The eye test

To find out how well you are able to judge proportions without measuring them, try this simple test. First choose your subject. It could be a live dog or you could use a photograph, but it should be a good picture, and the larger it is, the better. For this purpose, a photograph may, in fact, be better because the subject won't move while you are doing your test, and you'll more easily be able to check the accuracy of your drawing afterwards.

Now do a drawing of the dog, keeping it very simple. For this test, don't bother putting down any of the detail: if you wish, you need do no more than make a series of marks on the paper to indicate the proportions – the size of the head, and how long or wide you think the body, the legs and other parts of the dog should be in comparison to the head.

Checking for accuracy

Now compare your drawing with the dog in the photograph, or your live subject. Use the 'pencil method' already described – of course, if you have worked from a photograph, you don't have to do this at arm's length – and make a note of the results.

Now check your drawing in the same way. How well do the proportions in your drawing match those in the photograph, or those of the live dog?

In this drawing, I used the measuring method to check the size of the various parts of the body against each other. I then marked out these measurements to form the basis of my drawing. When the drawing looks right, the measuring marks can be erased.

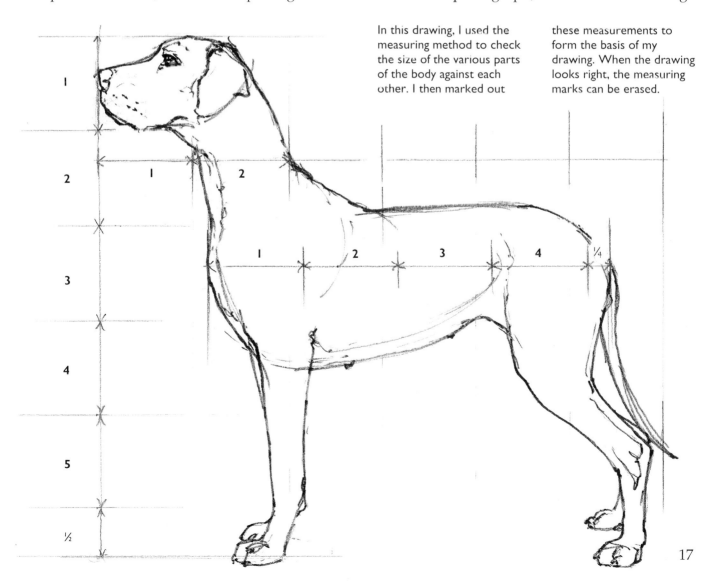

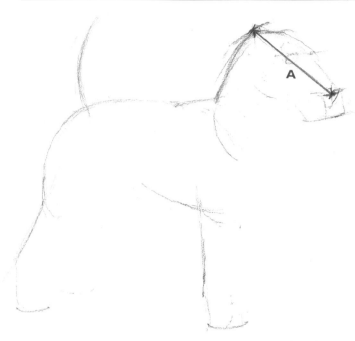

Training your eye

To start with, it is best to use the pencil method of measuring for your basic drawing – this will form the foundation of the finished work so it is important to get the proportions and angles right. As you progress, however, you will become more practised at assessing proportions and will be able to judge them by eye, only needing to use the pencil method to check your drawing if it looks wrong.

As you work, train your eye by continually comparing the sizes of the various different parts. For example, do the front legs appear longer than the back legs? How does the length of the neck compare with that of the legs? How does the head compare with the body? How do the widths compare?

1 To draw this Airedale Terrier, I first roughly sketched a simplified shape. Then I took the distance from the outer edge of the nose to the top of the head and used this as my measuring unit (A).

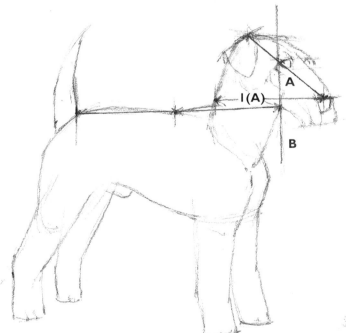

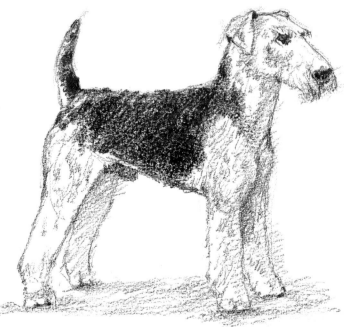

2 Holding the measure horizontally, I discovered that the distance from the nose to the back of the neck I(A) was the same as line A. Holding the pencil vertically, I saw the point at which the head met the neck, which lined up with the back of the eye (B). Holding the pencil vertically in this position also showed me the angle at which the dog held its neck.

3 When I had compared and corrected all the proportions and marked in the position of the key details, I worked up the finished drawing using a chinagraph pencil.

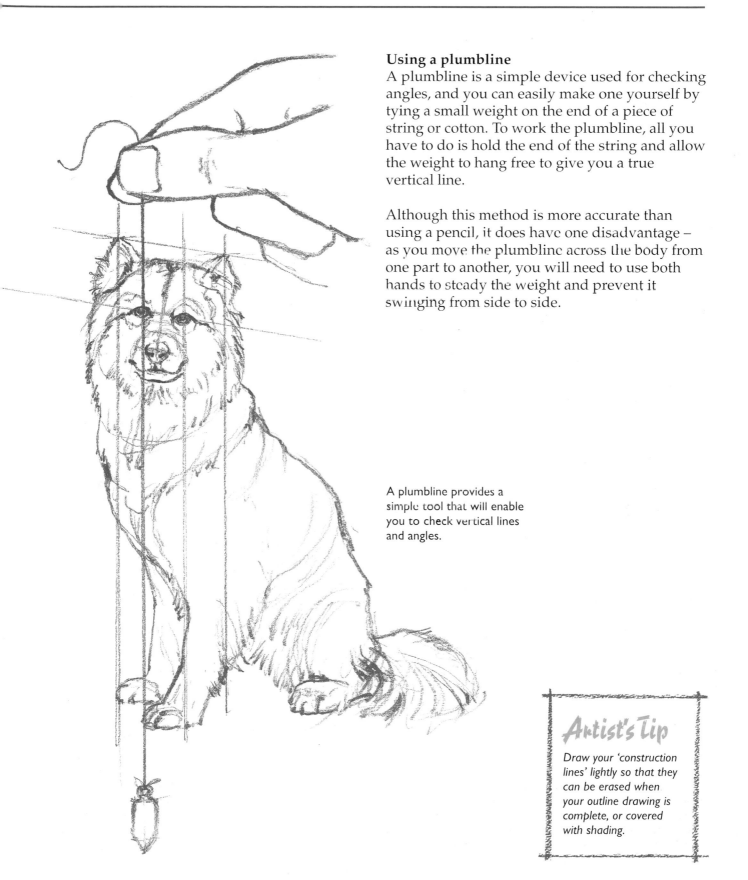

Using a plumbline

A plumbline is a simple device used for checking angles, and you can easily make one yourself by tying a small weight on the end of a piece of string or cotton. To work the plumbline, all you have to do is hold the end of the string and allow the weight to hang free to give you a true vertical line.

Although this method is more accurate than using a pencil, it does have one disadvantage – as you move the plumbline across the body from one part to another, you will need to use both hands to steady the weight and prevent it swinging from side to side.

A plumbline provides a simple tool that will enable you to check vertical lines and angles.

Artist's Tip

Draw your 'construction lines' lightly so that they can be erased when your outline drawing is complete, or covered with shading.

Structure and Form

If you take the trouble to learn a little about the underlying anatomy of a dog's body, it will give you a better understanding of the surface form – and you'll produce more convincing drawings.

Where to begin
The best way to start learning about canine anatomy is by finding suitable references to study. Your local library may stock books on dog health and care, and these will almost certainly contain helpful diagrams. Failing that, you

should be able to find books on dog anatomy at your nearest natural history museum.

Bones and muscles
Unless you intend to specialize professionally, you don't need to make a serious study. However, it would be most useful to develop a general knowledge of the way in which the muscles lie and interconnect, as well as the structure of the bones, especially those closest to the surface which affect its shape most.

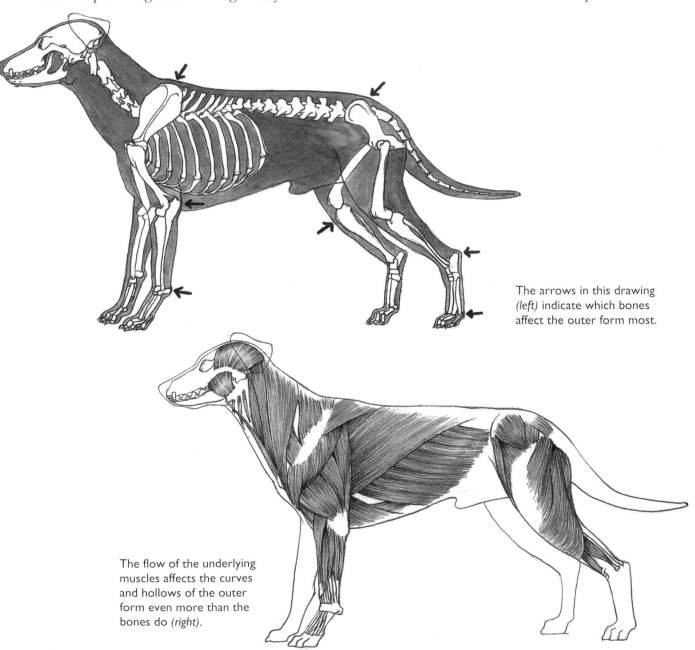

The arrows in this drawing *(left)* indicate which bones affect the outer form most.

The flow of the underlying muscles affects the curves and hollows of the outer form even more than the bones do *(right)*.

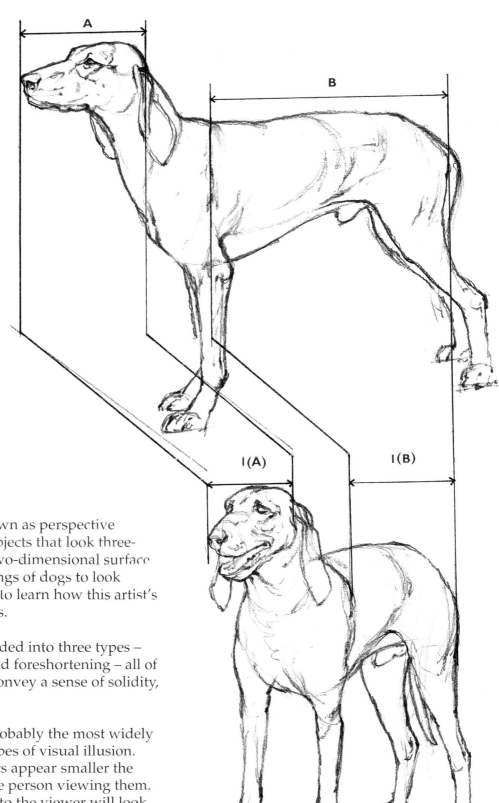

Linear perspective makes objects appear progressively smaller as they recede. To understand how it works, imagine that there are two lines on either side of the object you are drawing which increasingly slant inwards towards each other as the object recedes – if the lines continued they would eventually join together at a point known as the vanishing point. In these two drawings, compare lines A and 1(A) and B and 1(B) to see how this 'slanting' effect alters the shape of the dog's body.

Perspective

The optical illusion known as perspective allows artists to draw objects that look three-dimensional on a flat, two-dimensional surface. If you want your drawings of dogs to look convincing, you'll need to learn how this artist's 'trick of the trade' works.

Perspective may be divided into three types – linear, tonal or aerial, and foreshortening – all of which may be used to convey a sense of solidity, depth and distance.

Linear perspective is probably the most widely known of these three types of visual illusion. According to this, objects appear smaller the further they are from the person viewing them. So a dog standing close to the viewer will look larger than a dog further away, even though, in reality, they may both be exactly the same size.

Tonal perspective affects the depth of tone and definition of objects, and is caused by an atmospheric trick which progressively subdues colours and the differences between light and shade according to how far objects are from the viewer. On a dog's body, of course, one end is hardly far away enough from the other to make a difference – but for artistic effect, you could 'cheat' and exaggerate the gradual change in tone and detail to emphasize the sense of three-dimensional depth. This is what is known as 'artist's licence'!

This drawing illustrates the effect of tonal perspective *(left)*. The lighter tones used for the dog on the right push it into the background, while the darker tones of the dog on the left 'bring it forward'. The differences in tone have been deliberately exaggerated to produce this effect. Tonal perspective can be used to convey depth when the subjects are too close together to use linear perspective.

Artist's Tip

When producing a study drawing, keep to very simple shapes. You will then find it easier to understand the structure and to check angles and proportions.

In this sketch *(right)*, compare the amount of detail and weight of line used in the dog's head with that in the body.

Foreshortening is a form of extreme linear perspective. As the name implies, it describes the way perspective distorts the different parts of the same object, making certain parts appear to 'shorten' and become condensed as they recede. Sometimes these parts shrink so much that they almost disappear. When dealing with foreshortening, therefore, it is all the more important to use the measuring method described on pages 16–17, so that you draw what you *see*, not what you *know* to be there.

The foreshortening in this drawing of a Pointer *(above)* is so severe that the body and hind legs virtually disappear.

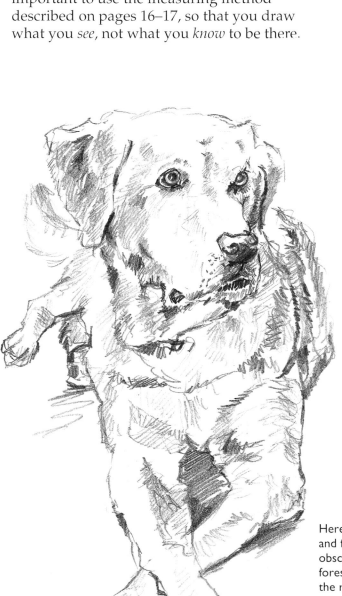

Here the Labrador's head and forelegs almost obscure the severely foreshortened body to the rear *(left)*. The brain translates the message sent by the eye, however, so that the drawing makes sense despite the degree of distortion.

Looking at Features

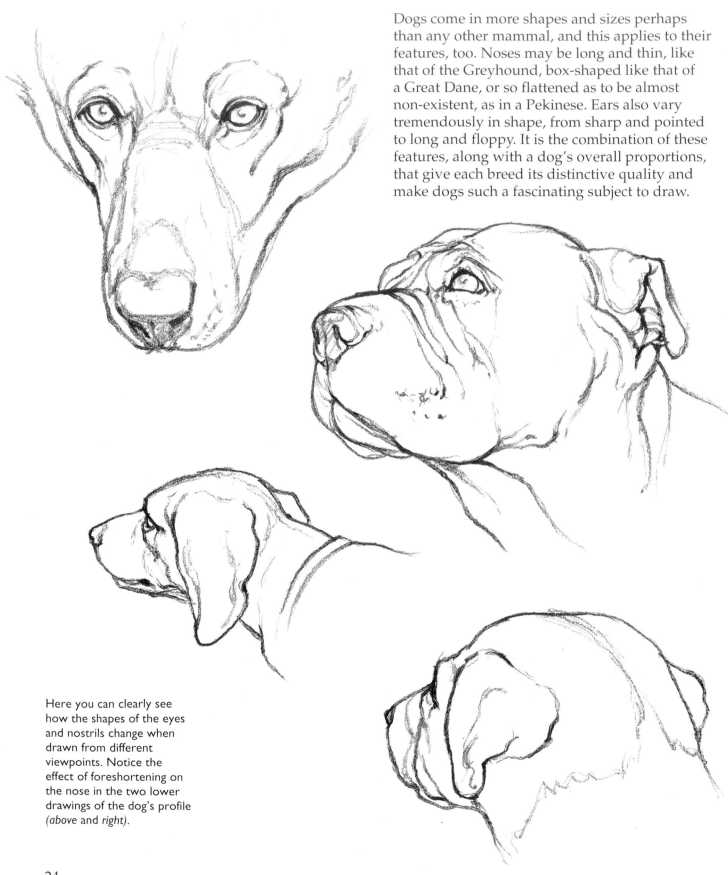

Dogs come in more shapes and sizes perhaps than any other mammal, and this applies to their features, too. Noses may be long and thin, like that of the Greyhound, box-shaped like that of a Great Dane, or so flattened as to be almost non-existent, as in a Pekinese. Ears also vary tremendously in shape, from sharp and pointed to long and floppy. It is the combination of these features, along with a dog's overall proportions, that give each breed its distinctive quality and make dogs such a fascinating subject to draw.

Here you can clearly see how the shapes of the eyes and nostrils change when drawn from different viewpoints. Notice the effect of foreshortening on the nose in the two lower drawings of the dog's profile (*above* and *right*).

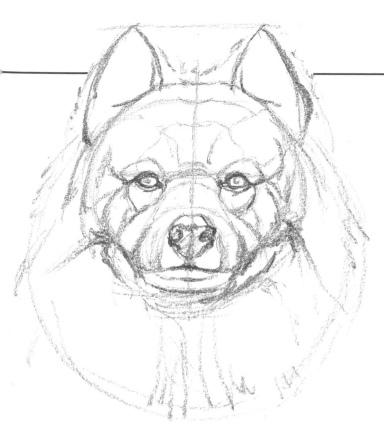

Changing viewpoints

When you change your viewpoint, you will be seeing a dog's features from a different angle so they will be a different shape. To get a feeling for each feature 'in the round', study the head from various positions. The three main viewpoints are full view (head on), full profile, and the three-quarter view which is a combination of both. Do sketches from these three viewpoints and observe how the shape of the features gradually shifts, flattening or elongating as the head turns.

The front view of this Pomeranian *(left)* gives little clue to the shape of its nose in profile.

Features

No single feature exists independently of the others: they all slot together to make up the whole like parts of a complex, three-dimensional jigsaw puzzle.

When you do your drawing, observe how the different features interrelate, and how one form flows into or moulds itself around the next. How do all these forms fit together to make up the total structure of the head? Where, for example, are the eyes positioned in relation to the nose? How do the ears 'sit'?

In profile, the Pomeranian's sharply pointed snout and curved forehead are revealed *(below)*.

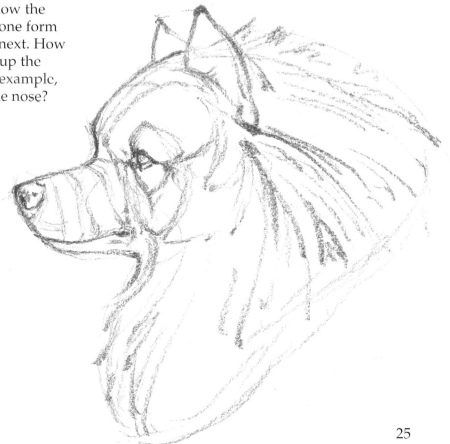

Artist's Tip

Imagine that you could trace a finger around a dog's head and 'feel' the shapes: where they are broad and flat, where they are rounded, or hollow. Now translate these contours into actual 'construction' lines on your drawing.

Ears

Ears are quite complex in structure – even those that appear simple at first can prove difficult to draw when studied in detail. Placing the ears correctly on the head can also be a little tricky.

To make ears easier to draw, use your pencil as a tool to check how the various features line up with one another. Check the relative angles, too, and if you wish include these guidelines in your drawing (you can always erase them later).

In the drawings below, you can see how a line drawn across the head shows how the base of the ear, the eye and the tip of the nose align with

each other. In the other drawings, notice how the guidelines and angles have been used to help establish the positions of the various features. Look, too, at how the ears seem to 'grow' out of the head.

The angle and shape of the ears can differ dramatically from one breed to another. Here I have drawn a few of the more obvious differences. Dogs can also move their ears, momentarily changing shape. For example, when showing fear or submission they will flatten their ears. They will also use one ear only to locate a sound which interests them, or prick up both ears in order to catch a sound.

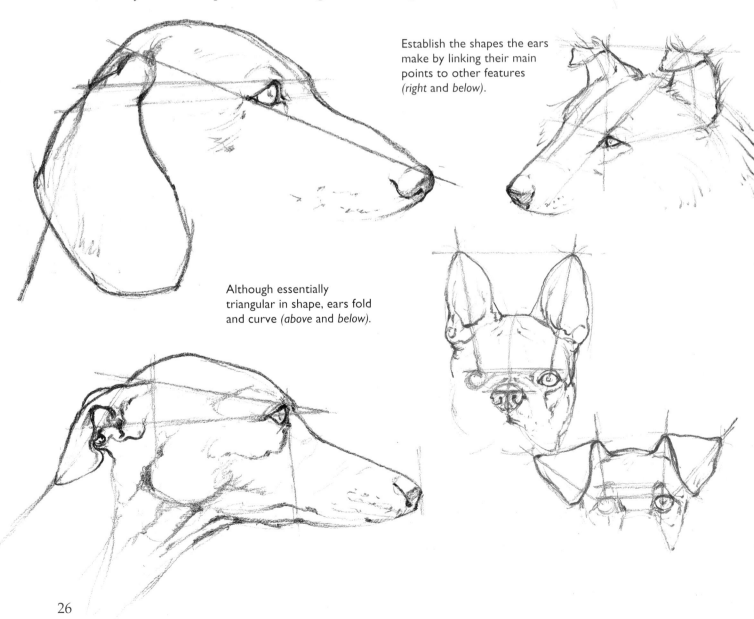

Establish the shapes the ears make by linking their main points to other features (*right* and *below*).

Although essentially triangular in shape, ears fold and curve (*above* and *below*).

Nostrils

Nostrils can be difficult to draw out of context, so I advise you to include as much of the surrounding area as possible when doing your study drawings, as this will make them easier to 'read' visually. Carefully study the structure of the nostril and what happens to it when viewed from different positions.

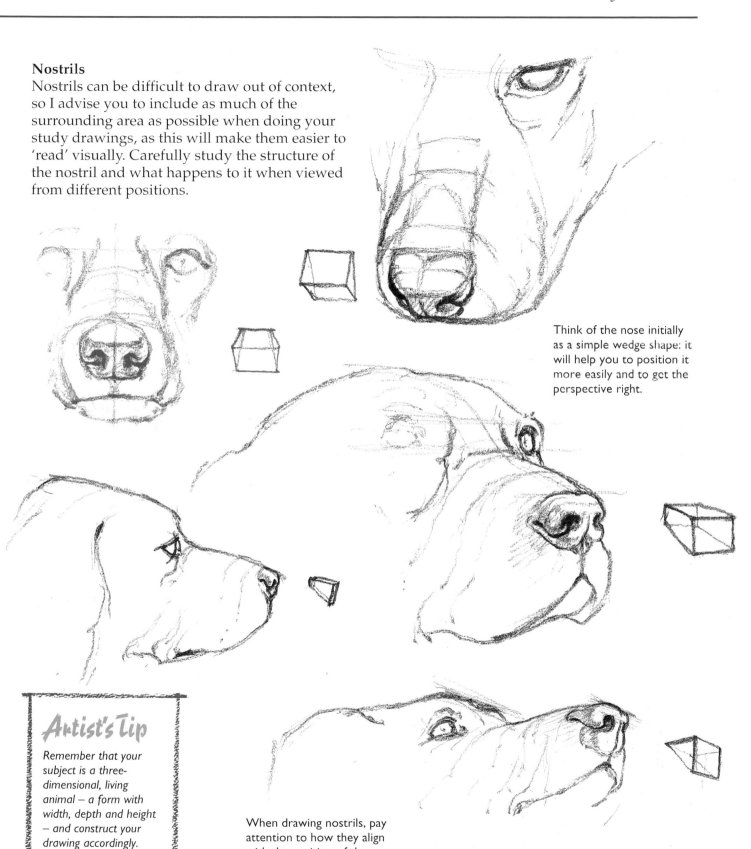

Think of the nose initially as a simple wedge shape: it will help you to position it more easily and to get the perspective right.

When drawing nostrils, pay attention to how they align with the position of the mouth *(above* and *centre).*

Different Breeds

There are perhaps more breeds of dog than of any other animal, each with its own distinct character formed by a combination of size, shape, coat and markings. It would be impossible to show all the different breeds in this book, and on occasion I have had to show a breed more than once in order to illustrate a certain point – as in *Choosing the Right Medium* – but, within the limitations of the space available, I have tried to show as many breeds as possible.

One way to familiarize yourself with the characteristics of the various breeds is to find visual references for them, and make drawings of these. As you build up your reference drawings, study what it is that makes one breed different from another. For instance, in what details does a Corgi differ from a Basset Hound? Look also at the way in which age affects a dog's appearance: how does a puppy differ from a fully grown adult of the same breed?

This Dachshund *(right)* was drawn on a semi-rough cartridge paper, using a B grade pencil. The most distinctive characteristic of this breed is the extreme shortness of its legs in relation to the head and body, which are of comparatively normal proportions.

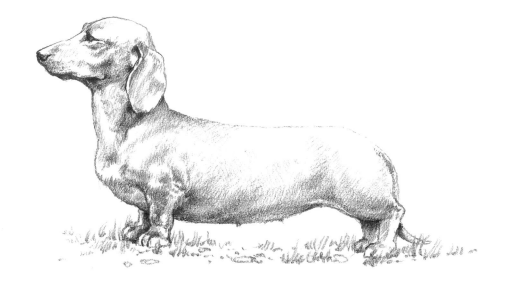

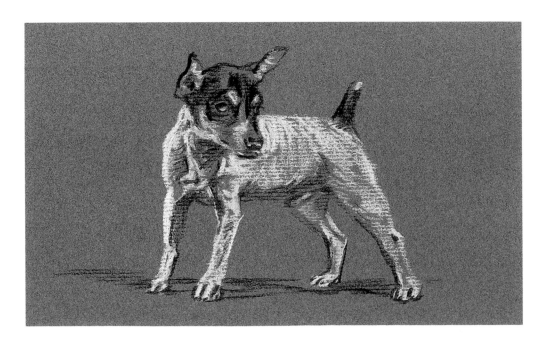

This Fox Terrier *(left)*, drawn in black and white conté on grey Ingres paper, has the muscular build of a dog made for running. Its head is fairly large in proportion to its body, and its back legs are widely splayed, with the strong backward thrust needed to propel it forwards.

Key differences

Apart from very obvious characteristics such as
the length of a dog's coat, leg length can be one
of the most striking differences between
different breeds. Other key features to look at
include the shape of the head – is the nose long
and pointed or square-shaped? The shape and
set of the ears is usually also very distinctive;
are the ears pointed and held upright, or long,
rounded, and floppy?

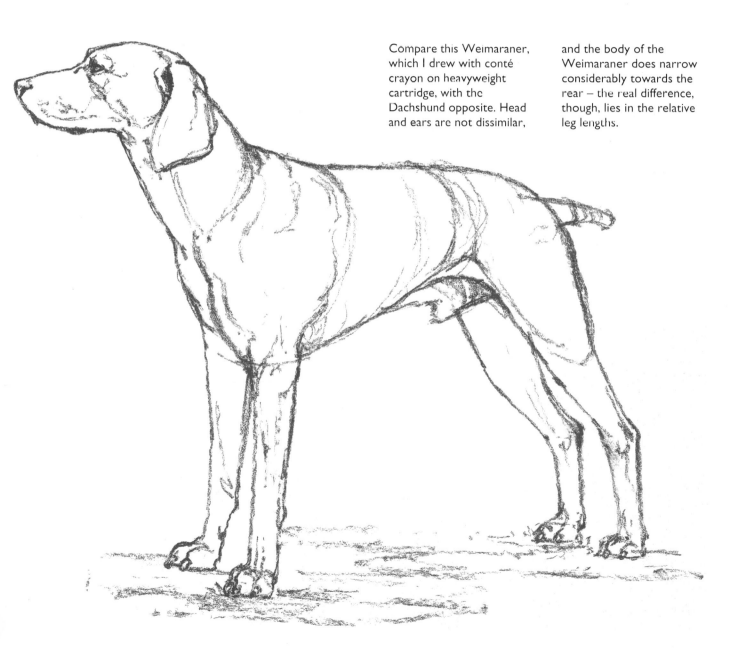

Compare this Weimaraner,
which I drew with conté
crayon on heavyweight
cartridge, with the
Dachshund opposite. Head
and ears are not dissimilar,
and the body of the
Weimaraner does narrow
considerably towards the
rear – the real difference,
though, lies in the relative
leg lengths.

Short-haired dogs

In short-haired breeds, the anatomical structure of the animal is fully visible and so has a powerful visual impact. For this reason, these are good breeds to draw to begin with, when you are trying to familiarize yourself with canine anatomy. Short-haired breeds include the more muscular types, many of whom are sometimes used as guard dogs, such as the Dobermann Pinscher, Mastiff, Bull Terrier, and Boxer. The Boxer, shown below, is a German cross-breed of the Bullenbeiszer and Bulldog.

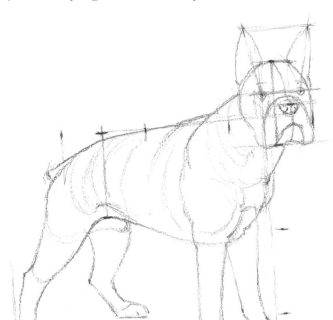

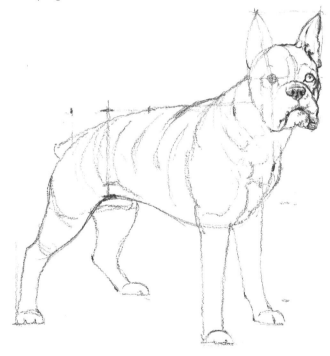

1 I began this drawing of a Boxer by doing a quick sketch, checking the proportions as I progressed.

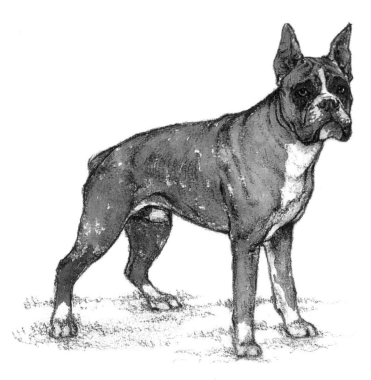

2 I then did a more detailed drawing with a charcoal pencil over the top of the basic sketch, which I then fixed using a can of colourless fixative.

3 Finally I put on a wash to indicate the coloured patches on the dog's coat.

Long-haired dogs

The anatomical structure of a long-haired dog is partly obscured by its coat, which then becomes one of its most striking features. Apart from those breeds that immediately spring to mind, such as the Afghan Hound, there are long-haired types in many other breeds. For example, the Dachshund already portrayed on page 28 appears not only as the well-known short-haired dog, but also in long-haired and wire-haired versions. In the Labrador group, in addition to the smooth-coated variety, there are the longer-haired versions such as Curly-coated, Flat-coated and Golden Retriever.

1 I drew this Golden Retriever with a B pencil on watercolour paper. Using the length from nose tip to the top of the head (A) gave me a handy measuring unit, allowing me to work out the proportions quickly. Holding the pencil vertically (B) helped me to establish the position and angles of the legs.

2 When I was satisfied with the proportions of the basic shapes, I began to refine the drawing, adding more detail and erasing unwanted guidelines.

3 Finally I completed the work using a no. 3 sable brush to lay a wash over the pencil drawing.

Colour and markings

Whether long- or short-haired, the markings on a dog's coat may be one of its most striking characteristics – the spots on a Dalmation, for example, are what, more than anything else, distinguish it from other breeds.

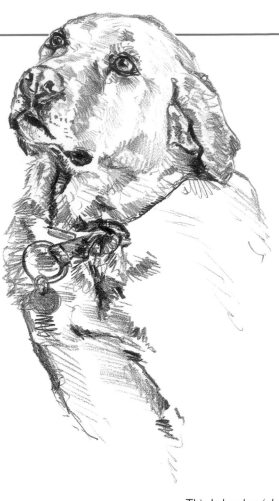

The Springer Spaniel *(below)* has a medium-length, curly coat, with distinctive patches and spots.

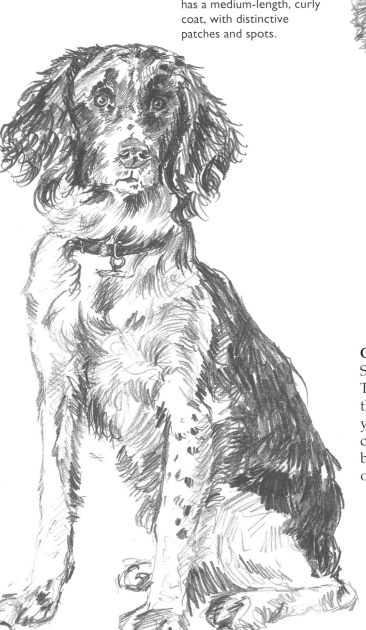

This Labrador *(above)* has a medium-length coat of a more or less even tone.

Graded tone

Some dogs, such as the Alsation and Yorkshire Terrier, do not have clearly defined patches on their coats, but subtle gradations of colour. If you are working in black and white, treat these changes in colour as tone, with the black on the back fading to the paler gold on the legs and other parts.

Wild dogs

Wild dogs live in many parts of the world, arguably the best-known being the Dingo found in Australia. For many years it was thought of as a domestic dog which had become wild, until fossilized evidence proved that it had lived on the continent at a time far earlier than that of the first settlers. Among other close relatives of the domestic dog are the wolf, jackal and coyote.

The only place you are likely to see wild dogs in the flesh would be in the confines of a zoo.

Although a zoo complex will prevent your subject from running off, the dogs will still be very much mobile and could remain in place for no more than a few seconds, so you will need to work quickly.

Not everyone lives within easy travelling distance of a zoo, in which case a visit to the local library would probably provide the references you seek. If you are working from a photograph, you will have no trouble in getting your subject to 'pose' for you for as long as you need, but you will not experience having a living, three-dimensional subject to draw.

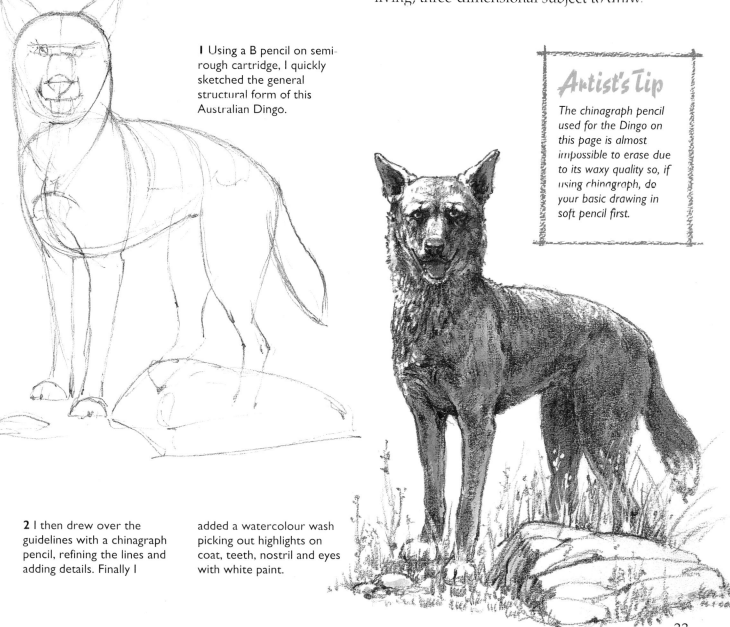

1 Using a B pencil on semi-rough cartridge, I quickly sketched the general structural form of this Australian Dingo.

Artist's Tip

The chinagraph pencil used for the Dingo on this page is almost impossible to erase due to its waxy quality so, if using chinagraph, do your basic drawing in soft pencil first.

2 I then drew over the guidelines with a chinagraph pencil, refining the lines and adding details. Finally I added a watercolour wash picking out highlights on coat, teeth, nostril and eyes with white paint.

Light and Shade

Most drawings begin life as simple outline shapes, with no sense of three-dimensional form – as you can clearly see in the two diagrams below. The first drawing is no more than a circle, but when shading is added it immediately assumes a convincing roundness and solidity.

Studying the effects of light

To understand the principles of light and shade, try to spend some time studying how light affects a particular object. A simple, rounded shape, such as a ball or round fruit, would be best for this exercise. It's also best to work indoors using a single source of artificial light, such as a torch or table lamp: unlike natural light, this type of light source is easy to control and will not produce complicated shadows. Move the light around your object, placing it close and then further away to see how this affects the 'modelling' – the sense of three-dimensional form created by light and shadow.

Highlights and shadows

As well as giving solidity to a flat object, light and shade also help to show where it curves outwards and where it sinks inwards. Essentially, light will highlight those prominent parts that it can reach. Sunken areas, on the side away from the light, will be in shadow.

Reflected light

Light can behave in an unexpected way. For example, the area most hidden from the light source is not always the darkest. This is because light may be reflected back on to the subject from surrounding surfaces, producing shadows that vary in intensity. Within these shadows there may be lighter patches, or 'low lights'.

In addition, the light may come from more than just a single source, although this one source may be more powerful than others.

Variations in tone

Modelling a drawing of a dog is a perfect example of how these subtleties in light and shade work. Unlike a simple rounded ball or orange, a dog is a complicated shape, made up of a whole series of curves and hollows.

To work out where the highlights, low lights and shadows fall, it helps to break your subject down into more basic forms. You will find many tones between the lightest and darkest areas, but you can simplify the exercise by just using, say, two or three tones: a dark one for the darkest areas, a mid-grey for the middle tones and white paper for those areas directly facing the light.

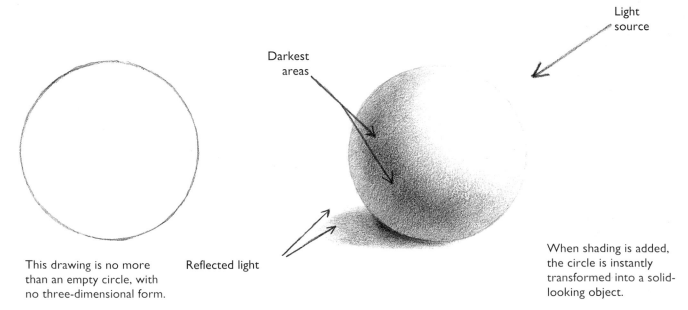

Darkest areas

Light source

Reflected light

This drawing is no more than an empty circle, with no three-dimensional form.

When shading is added, the circle is instantly transformed into a solid-looking object.

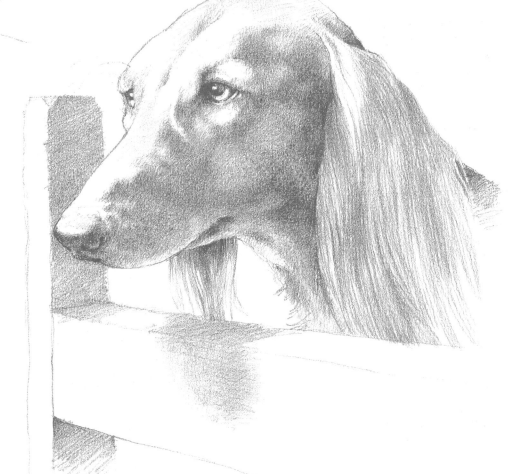

Artist's Tip

If your subject is not affected by reflected light, use artist's licence and add your own light to accentuate the three-dimensional quality of your subject.

1 In order to work out where the light and shade would fall, I broke down this head of a Saluki into raised areas and hollows. The arrows coming from the top left indicate the light source, while the arrows bottom right indicate the light reflected off the fence on to the underside of the head.

2 Using my previous study drawing as a guide, I used a 4B pencil on semi-rough cartridge to produce this finished drawing of the Saluki's head.

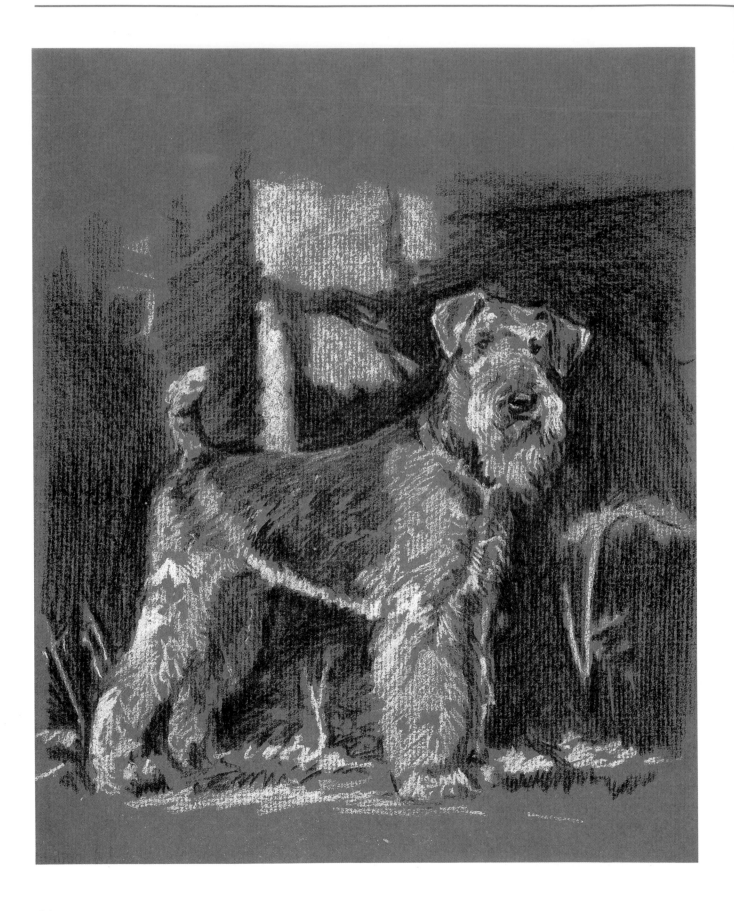

Natural light

Natural light is changeable, altering in direction and strength depending on the time of day. You need to bear this in mind if you are working in natural light – say, doing a sketch of a dog out-of-doors – because this will affect the intensity of the highlights and where the shadows fall. So that you don't have to keep amending your work, you might like, after drawing in your basic outlines, to make a mental note of the direction of the light source and lightly block in the shaded side as a reminder.

Cast shadows

As well as the highlights and shadows on an object itself, light also causes an object to cast its own shadows. If, for some reason, the light is coming from two or more different sources, this can create complications because one light could cancel out part, or all, of the shadow cast by the other light, as illustrated in the diagrams below.

When you begin studying shadows, therefore, keep it simple and make sure that the light is coming from a single source only.

Shapes and angles

Shadows fall at the same angle as the direction of the light, so look carefully at the angle at which the shadow falls in relation to the light source. Look also at the shape of the shadow. A shadow is never exactly the same shape as the object casting it, but a distorted version. The position of the light source will affect the length of a shadow: for example, a sun high in the sky will create short shadows, while a low sun creates elongated ones.

The surface on which a shadow falls also changes its outline. A relatively even surface, such as a wooden floor, will produce a fairly smooth outline; a rough surface, such as grass, will break up a shadow, creating a patchy shape.

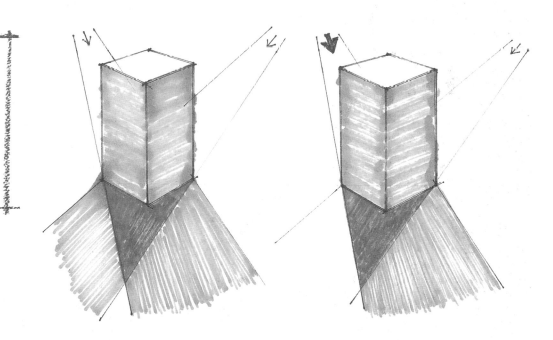

Artist's Tip

If your subject appears to be floating in space, 'anchor' it to the surface on which it is sitting or standing by adding a little shading underneath.

Black and white conté crayon on Ingres paper creates dramatic contrasts between highlight and shadow in this drawing of an Airedale Terrier *(left)*. This bold way with light and shade was much loved by certain Old Masters such as Rembrandt and Caravaggio, and was known as *chiaroscuro* – literally 'light-shade'.

In these two diagrams *(above)*, you can see the effects of light from two different sources. On the left, both lights are equally strong and soften part of the shadow cast by each other. Only the central shadow, that neither light can reach, remains dark. In the second diagram, the light on the left is so strong that it obliterates part of the shadow cast by the light on the right.

Texture and Markings

Conveying the various textures and markings on different breeds of dog not only takes skill, but also depends on choosing the medium – or media – that is most likely to produce the effect you want. The more you practise using different media, the better your skill in handling them, and the more appropriate your choice of medium will be.

Variety of texture

Throughout the many breeds you will come across three basic textures: short hair, which gives the dog a smooth appearance; long, flowing hair; and curly hair. In addition to these textures are the colours and markings of the various breeds.

Reproducing the soft quality of the hair on a dog's coat using only a pencil on a two-dimensional surface can seem a daunting task to the inexperienced. A method I like is to use a soft pencil on a smooth to semi-rough paper. You can produce very subtle lines by holding the pencil lightly, exerting very little pressure when drawing an area of hair affected by light, and increasing the pressure when drawing hair in the shaded areas. Initially I draw individual lines following the direction in which the hair is growing, taking care to place lines extremely close to each other for a velvety effect.

1 For this technique, you first do a simplified drawing in felt-tip pen *(left)*.

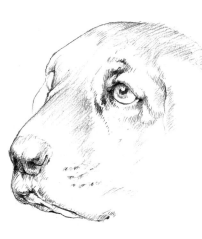

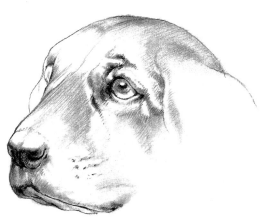

1 These two drawings show one of the ways to achieve a smooth effect with pencil. First do your pencil drawing, adding gentle shading where required *(above)*. Here I used a B pencil on smooth cartridge.

2 Then smudge the shading with your finger or French stick *(right)*. Notice how smudging makes the shading darker. If you find that some areas are too dark or hard-edged, dab them with a putty eraser. Smudging has a tendency

to even out the tones which can sometimes result in a grey drawing that lacks depth. If this happens, accentuate the darker areas to regain the depth.

2 Then dip a brush into clear water to make it damp but not too wet. Run the tip along the inside of the lines only to dissolve the ink slightly and create a shaded effect *(above)*. This technique works best on paper or board with a smooth surface.

1 This is Sam whom I was kindly allowed to draw by his owner Pam. Sam was drawn with a 4B pencil on semi-rough cartridge. I first roughly drew the shape. Using the length from the tip of the nose to the top of the head (A) gave me a measuring unit, allowing me to check the proportions.

2 When I was satisfied with the proportions of the basic shapes, I began to refine the drawing, adding more detail.

3 Finally, I completed the details showing the flow of the hair and adding shadings, as described above, to indicate the three-dimensional shape of the dog.

Artist's Tip

Creating a sense of texture is to do with 'seeing' what something feels like. So, when working out what effect to create, imagine you could touch your subject. Does it feel smooth and velvety? Coarse and rough? Choose your materials accordingly.

Behaviour and Expression

Dogs display a range of both body and facial expressions, from terrifying aggression to sheer joy when greeting their owners. The dog is a hunter and pack animal by nature, which makes it sociable within its own group but prepared to defend its territory against outsiders.

This instinct is still strong and may be seen in the present-day dog, and means that many different breeds make excellent guard dogs. Up until several years ago, we had always had a dog in the family. Each animal was of a different breed, yet each showed this territorial instinct. Initially the dogs would behave aggressively to anyone approaching the house until cordially greeted by a member of the family. Then they would, sometimes reluctantly, accept the stranger as a new member of the 'pack' – the family.

Photographic reference

Dogs are very active animals, particularly the younger ones. I remember the last dog we had loved to play with a balloon. We would toss it into the air and he would jump up and try to grab it in its teeth. Another interesting action pose he got into was suddenly to roll on to his back for a few seconds and just as suddenly jump up again.

It would be almost impossible to capture such behaviour on paper, as it was happening. Apart from the sheer physical difficulty of having to draw quickly enough to produce any marks at all, there is also the impossibility of being in the right place at the right time with the right equipment! This is where a camera can be an invaluable tool. I have seen numerous photographs showing just this type of action.

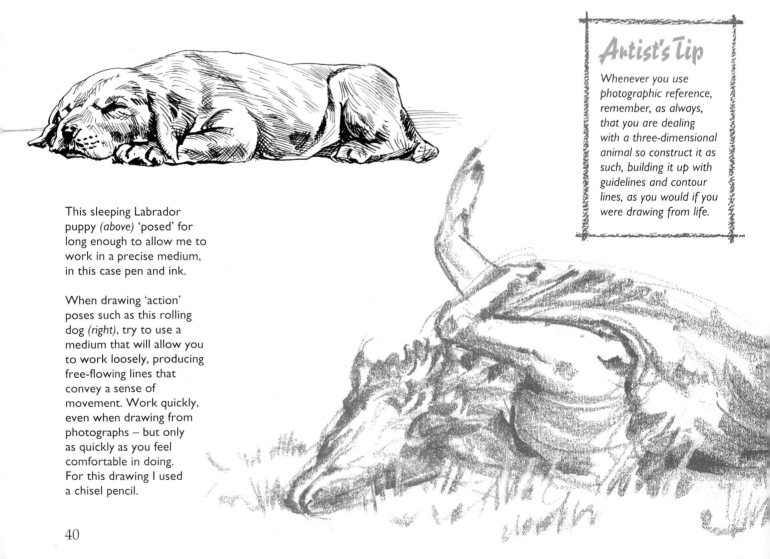

Artist's Tip

Whenever you use photographic reference, remember, as always, that you are dealing with a three-dimensional animal so construct it as such, building it up with guidelines and contour lines, as you would if you were drawing from life.

This sleeping Labrador puppy *(above)* 'posed' for long enough to allow me to work in a precise medium, in this case pen and ink.

When drawing 'action' poses such as this rolling dog *(right)*, try to use a medium that will allow you to work loosely, producing free-flowing lines that convey a sense of movement. Work quickly, even when drawing from photographs – but only as quickly as you feel comfortable in doing. For this drawing I used a chisel pencil.

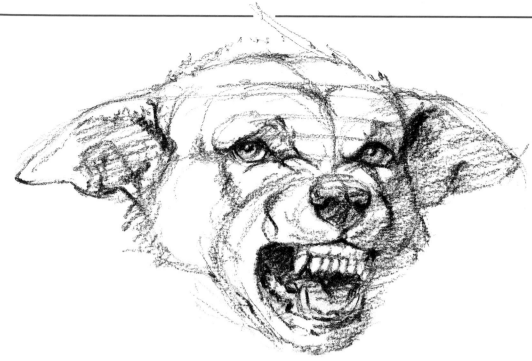

I used a 2B charcoal pencil on watercolour paper for this drawing. The pencil gave me a range of shades, from black to light grey. When used on a rough surface, it produced a bold effect which was ideal for conveying the aggressive display of this dog.

Odd angles

Even with the help of photographic reference, however, this type of behaviour can be difficult to portray convincingly because dogs are not normally seen from these angles and so, when they are, they have a tendency to look odd. If you practise drawing from different and unusual viewpoints, you will become more familiar with the whole shape of the dog and not merely the usual overhead views.

Showing expression

Dogs are intelligent and consequently very emotional animals, capable of showing a range of feeling from angry aggression to total submission. There are, however, certain breeds which seem perpetually to show one particular expression; this is not due to an emotional state, however, but merely to the facial characteristics of the dog.

To add to the confusion, you will find that certain features behave in the same way when a dog is displaying different emotions. You will only be able to guess the true emotion by looking at how the features combine. For example, a dog will lay back its ears when showing aggression, when frightened, and when being submissive. It will also reveal aggressiveness or fear by baring its top teeth, but it will either keep its mouth closed or open it just slightly when showing submission. So, to portray a particular emotion, you will have to understand and correctly combine several elements such as ears, eyes and posture.

A word of caution here: just because a dog is frightened does not mean that it is harmless. A frightened dog is a dangerous dog, so take care.

Eating and drinking

To start with, it would be sensible to choose something less challenging than a dog jumping or rolling about on the ground. A dog in the process of eating or drinking would make a good subject.

I realize that dogs have a tendency to devour their food in a matter of seconds, but this time can be greatly extended by giving the dog something to chew or gnaw at. This could be one of the artificial bones made of an extremely hard, edible, meat-flavoured substance available in some pet shops, but anything that the dog cannot gulp down and therefore would have to take time in consuming would serve the purpose. This would give you the chance to choose your viewpoint and either do one carefully measured drawing, putting in as much detail as possible, or to do two or three quick sketches from different angles.

A dog will invariably lie down when gnawing at a bone, but will stand when drinking or eating soft food, so you will have to bear this in mind when deciding which situation to set up.

Flexible medium

Because of its flexibility, watercolour is an excellent medium to use for portraying dogs involved in different types of behaviour. It is a medium which I enjoy using a great deal, for it has an aesthetic quality which I like very much. You can be exact with it, keeping it tight to produce realistic, detailed work, or use it loosely to produce fresh, free-flowing work. I also like to combine it with coloured pencils, drawing over the watercolour with pencil to sharpen up or emphasize details.

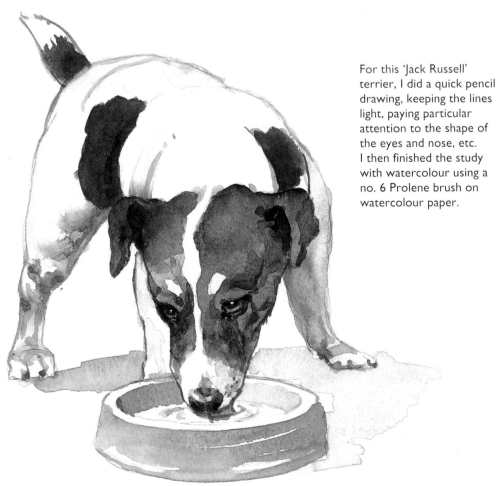

For this 'Jack Russell' terrier, I did a quick pencil drawing, keeping the lines light, paying particular attention to the shape of the eyes and nose, etc. I then finished the study with watercolour using a no. 6 Prolene brush on watercolour paper.

To draw this Chien, I used a felt-tip pen. It is a good tool to choose when you want to draw quickly, and can be used on both smooth and rough surfaces. I prefer one that has been in use for some time because it will have lost its new-ink quality and so will produce a more subtle line.

Artist's Tip

Don't throw away your old felt-tip pens until they are completely dry and unable to make a mark – a dryish pen produces a subtle and interesting line.

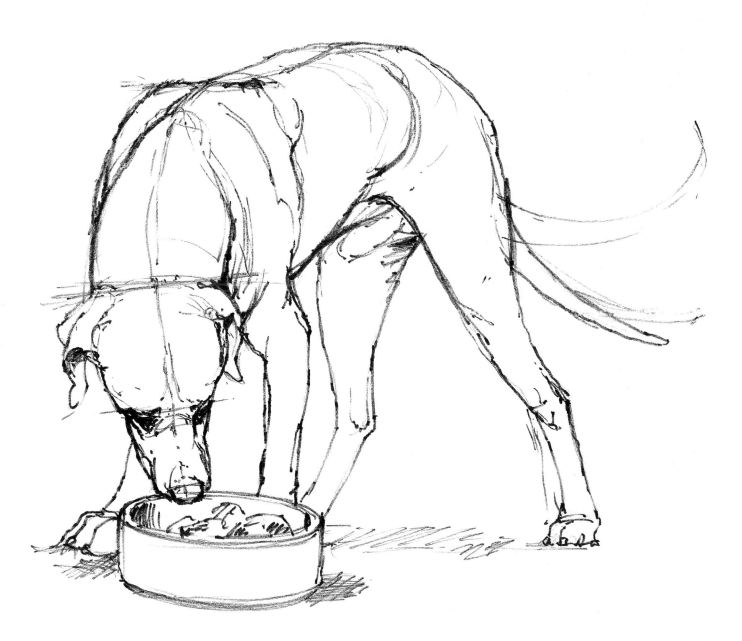

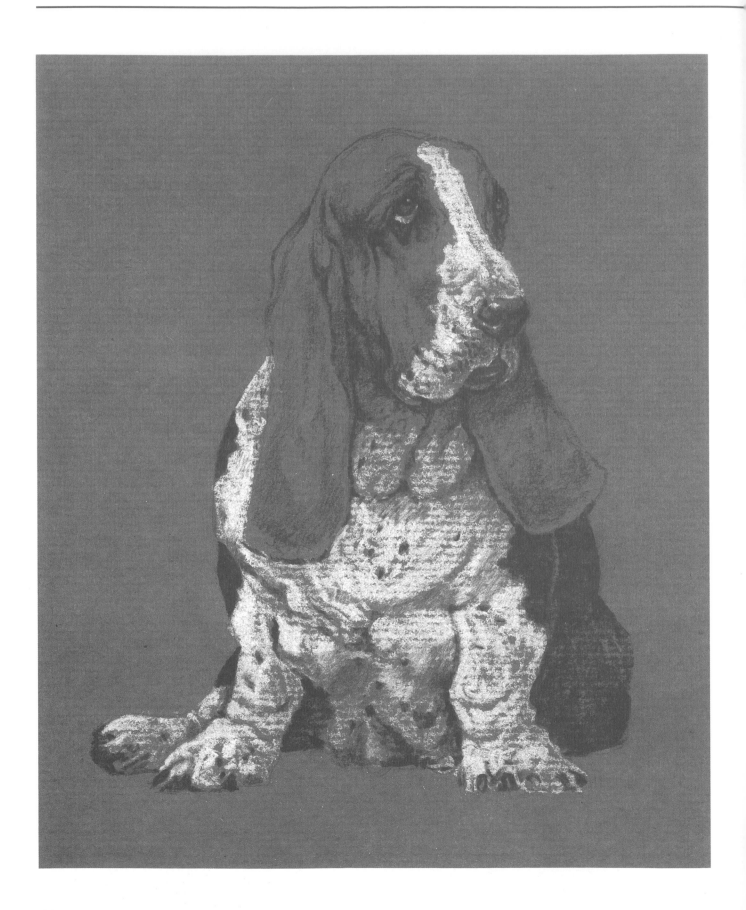

Working from life

If you decide to go out-of-doors in search of suitable subjects, limit yourself to one medium only to begin with. For example, if you choose to work in pencil, then take only one medium-grade pencil (say a B), a sharpener and, of course, a sketchbook. You will not need an eraser: if you feel you have made a mistake by drawing a line in the wrong place, simply draw it again in the right place. You can, if necessary, erase the incorrect one later, but I would leave it, for it will show you where you went wrong and how you corrected it – which is all part of the learning process.

You can add to your outdoor equipment as you gain experience and become more confident about working out in parks or whatever your chosen location. In the meantime, however, avoid cluttering yourself up with unnecessary gear until you have tried out the various media available, to find out which you prefer.

Artist's Tip

When doing a pastel drawing, like that of the Bassett Hound, you might overwork it by placing too many colours on top of each other. If so, spray with fixative and, when dry, work over your drawing again.

This Bassett Hound *(left)* is a perfect example of how the physical characteristics of some breeds give them a fixed expression – the Bassett's floppy ears, droopy eyes, and hanging jowls make it look permanently lugubrious. I produced this drawing on the matt side of brown wrapping paper, using just two pastels – a white and dark brown – with the paper representing the middle tone.

I found the fluid quality of water-soluble coloured pencil perfect for this quick sketch of a 'Jack Russell' tugging at its lead *(above)*.

Classic canine behaviour: two dogs sniff each other in greeting *(below)*. Capture such fleeting moments in sketch form first, then add to them later with, say, an ink wash, as here.

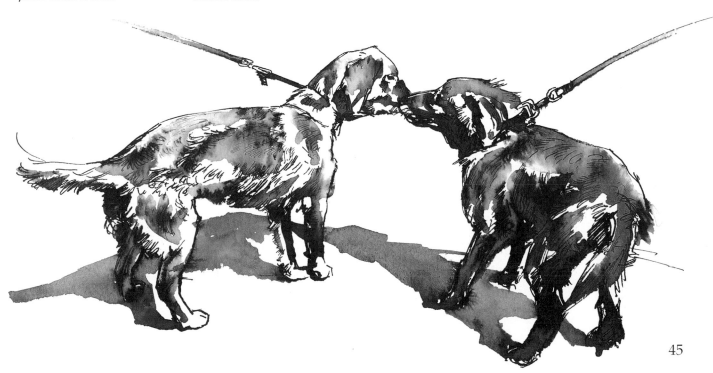

Movement

A running or jumping dog simply moves too quickly for the eye to follow, and is therefore impossible to draw from life. The parts that move most rapidly are the legs. Their position is constantly changing and, in fact, follows a strict sequence made up of a whole series of small, individual movements, rather like the frames in a cartoon film. All this happens too fast for the human eye to capture – but not too fast for the lens of a camera.

Single frames
Before the invention of photography, people simply had to guess at the way in which the legs and torso of different animals moved. Now, with the help of photographs, videos and television, people are able to 'freeze' these sequences of dogs and other animals in motion, and so identify exactly what is happening at any moment and – perhaps most importantly – how the separate movements all synchronize.

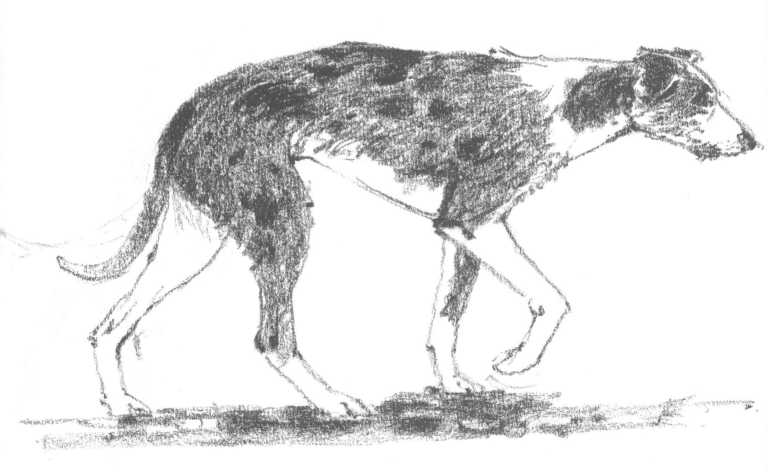

You may, through lack of experience, feel incompetent and therefore lack confidence in tackling dramatic movement at the outset. If so, practise on walking rather than running or jumping dogs. This drawing of a Lurcher is an example of what I mean. It is walking slowly toward something which obviously interests it. A situation like this could be set up, or a friend could be persuaded to walk a dog on a lead.

At first, just study the movement of the legs. Only when you feel that you understand the movement should you start to draw. This drawing was done in conté crayon on semi-rough cartridge paper.

I remember seeing a series of photographs taken with a camera normally used for sporting action shots – the type that automatically takes individual pictures in rapid succession. The result was a series of stills clearly showing the sequence of movements a dog goes through when it leaps up in the air to catch a ball from a standing position.

Drawing from memory

If you are drawing from life, the best method I have found is to spend some time simply observing your subject without drawing anything. Then, while the information is still fresh in your mind, quickly put down on paper everything that you can remember.

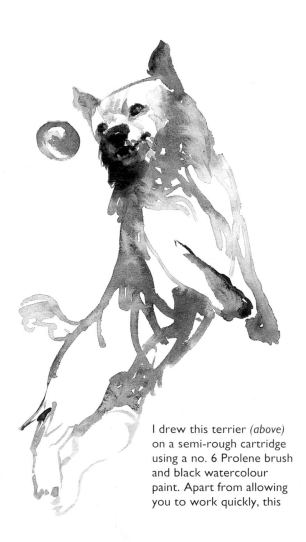

This drawing of an Australian Kelpie *(right)* was done with a charcoal stick. The point of the charcoal was used to create fine lines and the side of the stick for broad flat areas. The quality of the media used on the two jumping dogs on this page both help to portray movement.

I drew this terrier *(above)* on a semi-rough cartridge using a no. 6 Prolene brush and black watercolour paint. Apart from allowing you to work quickly, this medium also produces interesting tones. I then used a damp brush to lift off areas of paint and so lighten and pick out parts of the mouth and teeth.

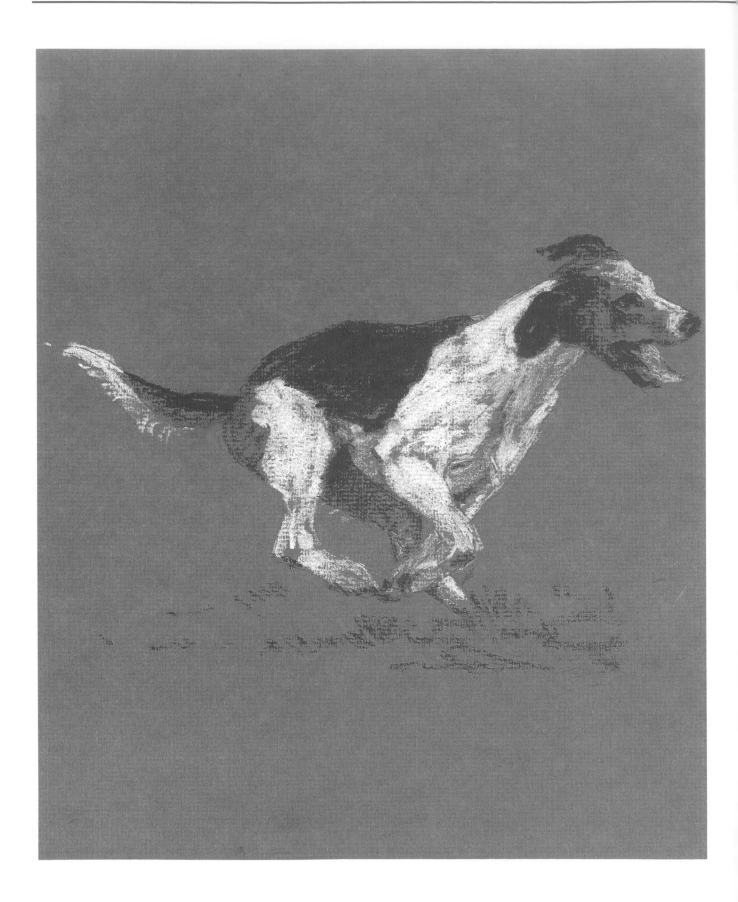

The rhythms of movement

When you are drawing a moving dog, try not to think in terms of producing a perfect, finished drawing. What you are doing is primarily an exercise, the purpose of which is to capture the essence of the dog's body movement. You are looking for the rhythms in the body – the flowing sweep of lines and angles. If you can get these rhythms down first, concentrating just on the basic shapes, you can always add in details later, if required.

Large and loose

Paying too much attention to detail will distract you from the essentials of movement. To maintain more of an over-view and to get as much movement into your lines as possible, it's best to draw quickly – and large. This will give you the freedom of movement to produce the 'action' lines. Take care, however, to choose a scale with which you feel comfortable: if you force yourself to draw unnaturally large, this will only inhibit rather than liberate your style.

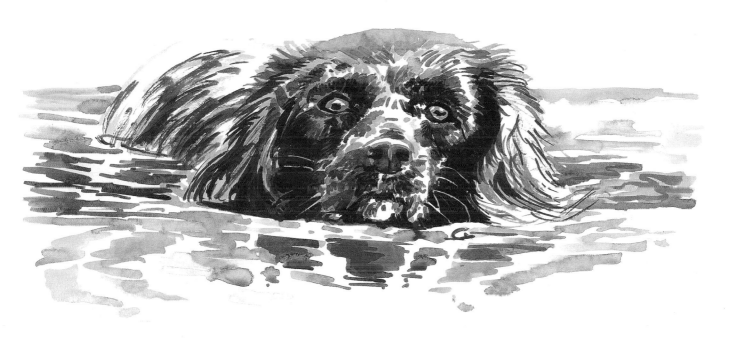

The first stage of this drawing of a running Foxhound *(left)* was a simple pencil sketch which was then completed by quickly blocking in, using white and very dark brown pastels. Treating the subject in this free, sketchy way adds greatly to the feeling of movement.

In this watercolour drawing of a swimming Springer Spaniel *(above)*, a feeling of movement is not instantly apparent because the dog is viewed head-on and its legs – the greatest indicator of movement – are hidden. The fluid quality of the medium, however, the spreading, floating ears, and the disturbed water surface all contribute to a subtle sense of motion.

Artist's Tip

When you are trying to get movement into your lines, don't force the pace but draw as quickly as is comfortably possible. With practice, you will automatically begin to draw faster and with greater confidence.

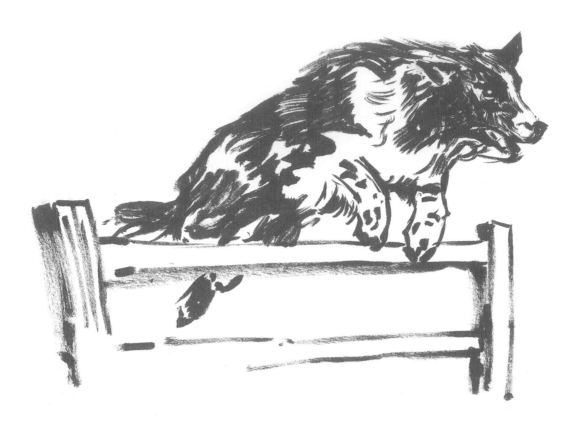

The movement of this Border Collie as it leaps the fence *(left)* is almost identical, in three-quarter view, to the running movement of the dog below. It was drawn in felt-tip brush-pen.

A dog walking, trotting and running *(below)*. In the middle drawing, the dog's legs are bent more than in walking and its front foot is slightly off the ground, giving it a springy bounce. The running dog at the end is effectively doing a series of controlled leaps as it bounds along.

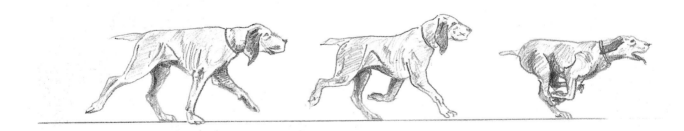

Focusing on the parts

Instead of trying to draw a whole dog to begin with, you could, if you prefer, first focus your attention on individual parts of the body. For example, you could study how the front leg bends and how the angle between top and bottom parts changes as the dog walks. How about the difference in angle between the head and neck? As your confidence grows, you could then tackle the whole body – remembering, as always, to build up your drawing from the basic shapes, lines and angles.

If you practise this system, eventually your observation, understanding and memory will improve sufficiently to enable you to reproduce – with a degree of accuracy – most of the different body shapes in movement.

A new angle

When you feel more confident in portraying movement, try a new challenge – drawing dogs from different angles. You could perhaps attempt drawing a dog from a low viewpoint, which involves looking up at the animal from underneath as it leaps into the air to retrieve a thrown object; or you could draw a dog running either towards you or away from you. Your earlier practice in drawing individual parts in motion can prove invaluable here.

This charcoal pencil drawing of a Poodle really epitomizes speed. The bold, almost scratchy quality of the lines creates a very dynamic sense of motion.

Artist's Tip

Drawing a dog from an unusual viewpoint can be tricky. However, if you develop a firm grasp of the rules of foreshortening, you will be able to produce a convincing drawing. These rules apply whether the animal is moving or still.

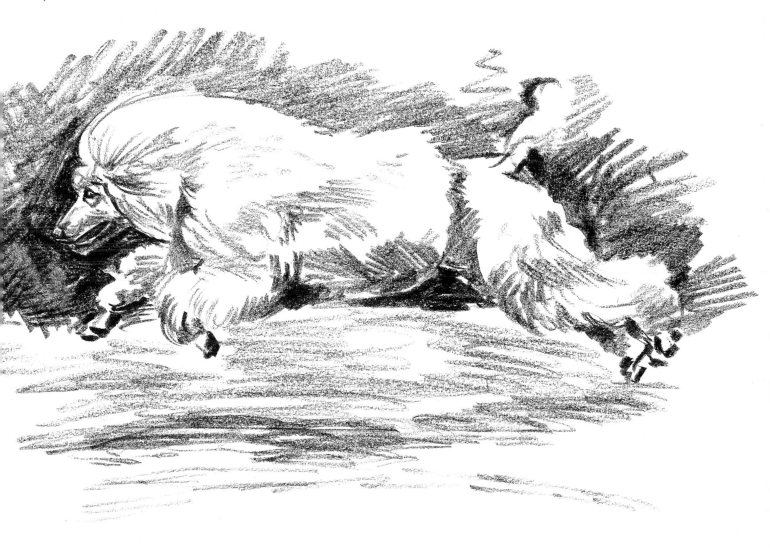

Sketching

Whatever art or craft you wish to pursue, the only way to improve your skills is by practice. For the artist, sketching is an excellent way of developing drawing skills and, as such, is an important part of the learning process: not only does it sharpen your powers of observation, but it also builds up your knowledge and understanding of structure and form.

Sketching styles

Sketching can take various forms. You may, for example, use your sketchbook to make quick scribbled drawings in an attempt to capture movement. Alternatively, you could do detailed drawings of various parts of the body to be used for future reference, thereby improving your knowledge of anatomy.

You could also use sketching as a way of experimenting with and learning more about different media and techniques.

I used a ballpoint pen for these two sketches. The smooth-running nature of ballpoint makes it a very suitable medium for producing quick drawings.

Artist's Tip

If you want to do some quick drawings on very rough paper, be sure to choose an instrument that will flow smoothly over the surface without getting snagged. For instance, it would be unwise to use a sharp, pointed nib on a very rough watercolour-type paper when you are trying to work at speed.

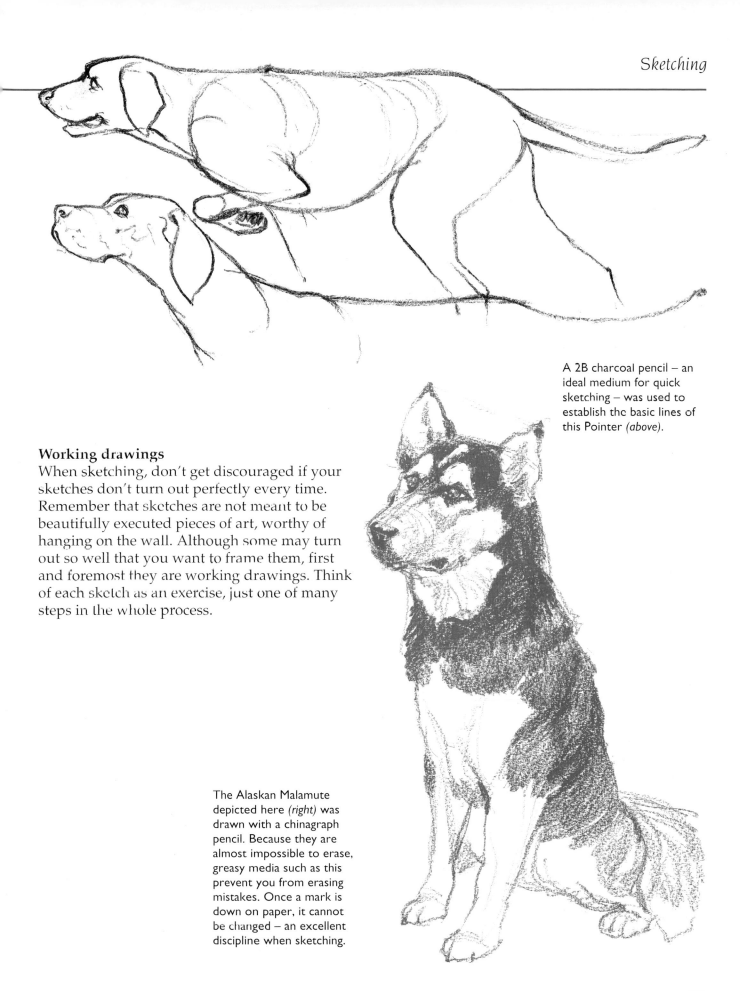

A 2B charcoal pencil – an ideal medium for quick sketching – was used to establish the basic lines of this Pointer *(above)*.

Working drawings

When sketching, don't get discouraged if your sketches don't turn out perfectly every time. Remember that sketches are not meant to be beautifully executed pieces of art, worthy of hanging on the wall. Although some may turn out so well that you want to frame them, first and foremost they are working drawings. Think of each sketch as an exercise, just one of many steps in the whole process.

The Alaskan Malamute depicted here *(right)* was drawn with a chinagraph pencil. Because they are almost impossible to erase, greasy media such as this prevent you from erasing mistakes. Once a mark is down on paper, it cannot be changed – an excellent discipline when sketching.

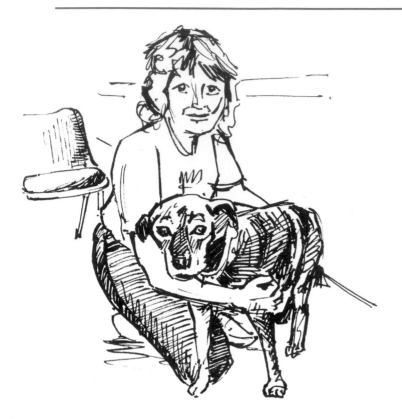

Choosing by memory

Here is a method that will help you to improve your powers of observation and selection. First, use your eyes to study the dog, taking note of the basic shapes and angles; then, when it's still fresh in your mind, quickly draw as much as you can remember without looking up again until you have drawn every bit of information that you have memorized.

By drawing from memory in this way, you will realize what information you need in order to make a presentable drawing and – just as important – what to leave out. When you come to repeat the exercise, you will then be more experienced as to what to look for and record.

Even when subjects are prepared to pose, you may still only have time to do a quick sketch *(above)*.

If you have sketchbook and drawing tools at hand, you will be ready to record your impressions while the memory is still fresh *(right)*.

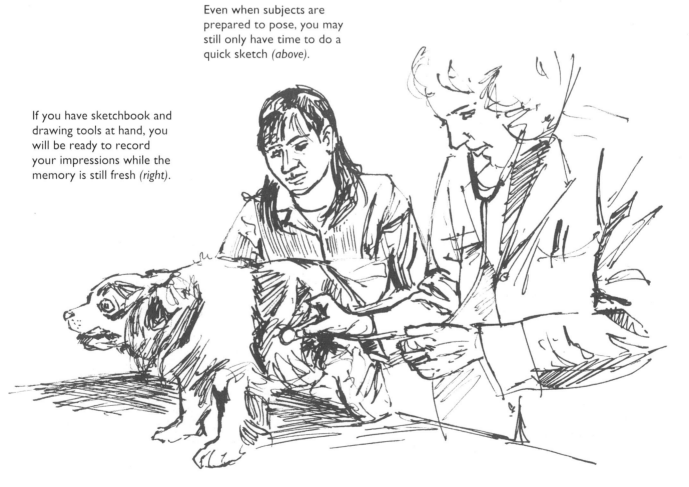

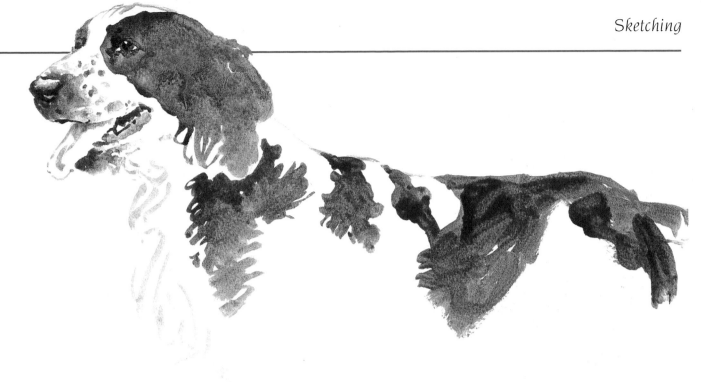

I used liquid acrylic paint to produce this sketch of a Welsh Springer (above). I applied it with a no. 6 Prolene brush in my watercolour sketchpad. This versatile, sensitive medium can be used directly from the pot to produce strong, dark tones or watered down for a more subtle effect. Additionally you can use it to cover a large area quickly and to produce fine lines when required.

Artist's Tip

Never throw away or destroy your old sketchbooks. They could be of some help to you at a later date, and will also be a fascinating indicator of how your drawing is progressing.

Good practice

Try to get into the habit of carrying a sketchbook of convenient size and some basic drawing tools around with you whenever you can – this is good artist's practice. Then, should you unexpectedly spot something you would really like to jot down on paper, you will have everything you need at hand.

As well as being good drawing practice, the drawings you do in your sketchbook can also provide invaluable reference when you are unsure of what a particular feature looks like, and need more information.

Brush-pen allowed for rapid sketching of this brief moment in time – a Scottish Terrier begging for its ball (below).

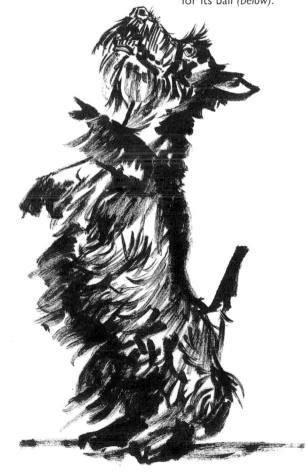

Composition

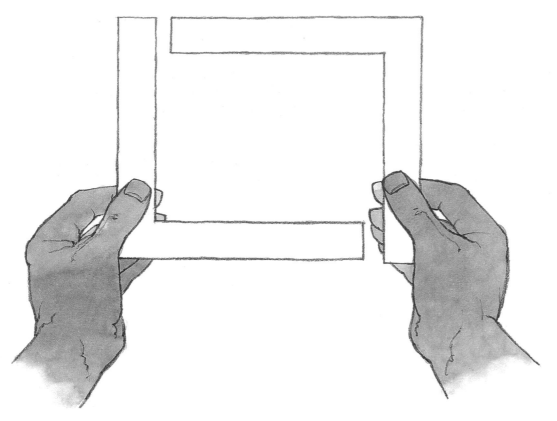

'Framing' your subject or composition is a useful technique when deciding on your arrangement. First cut out two corners from card, as long as you want, then turn them into a frame by holding them together at right angles. By sliding these two pieces together or pulling them apart, you will be able to establish the shape and proportion of the area taken up by your subject *(left)*. This will help you when planning your drawing on your paper.

Laying down a larger version of the corners over your drawing will also help you decide on the size and proportions of your mount and/or frame *(below)*.

The term 'composition' is used to describe the arrangement of various elements so that they produce a balanced picture which is pleasing to the eye. When composing your picture, it is helpful to bear a few general rules in mind.

Deciding what to include

One of the first rules is that you don't have to include everything you see. For example, you may, after studying a group of dogs, or people and dogs, decide to leave out one or more because doing so would improve the composition. You may even consider moving a dog or person to a different position.

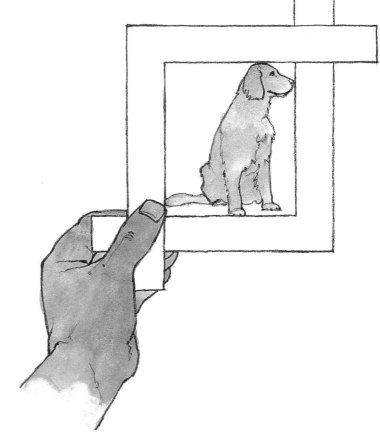

You would not be 'cheating' by doing this – on the contrary, you would be creatively making the arrangement more interesting or even exciting. The same principles apply when drawing a single dog. You could omit or underplay certain areas in order to concentrate on one particular part, such as the head.

The focal point

Every composition should have a particular area or spot to which the eye is drawn because of its special visual quality, or because the arrangement of the other elements in your picture leads to it. This is the 'focal point'.

Imagine, for example, that you are looking at a row of people at a dog show. Each has, on a lead, a small, dark-coloured dog with the exception of one, who has a large, light-coloured Great Dane. Your eye would be drawn to this dog because it is different from the others, making it the focal point of the group.

In this composition *(below)*, the woman with her dog on the far left is what first draws the eye, forming an off-centre focal point. The eye then travels the diagonal formed by the other groups to the sketchily drawn clump of trees, which balances the other elements without competing for attention.

If this dog were at the very end of the row, it would make for an uncomfortable arrangement, so it would be better to move it to a more central position. This focal point could be further accentuated by, say, making the clothes of the handler brighter than the rest.

Off-centre interest

By suggesting that you move the dog further into the picture, I don't necessarily mean *literally* into the centre – this would be too obvious. Your picture would look more interesting if the dog were positioned slightly to one side of centre.

A central focal point can be successful, but it needs to be handled with great care and thought to avoid it looking too contrived.

> ## Artist's Tip
>
> *Never immediately accept the arrangement you see in front of you. Try looking at it from another position or, if you have a group formation, study it to see if there is a better composition contained within the group. Use the framing method to help you.*

In Setting

When you are doing a study drawing of a dog, your intention is to learn more about the structure of the animal, its surface texture, etc, so its surroundings will not be important. You might also draw just the head if you want a drawing to frame and display on the wall. As a general rule, however, including some of the animal's surroundings will add to, rather than detract from, your drawing.

Finding your location
There are many places you can go to find dogs in different settings. For example, there are dog kennels scattered all over the country, which you could look up in a local telephone directory. Another location where you can find your subjects are dog obedience classes, which sometimes advertise in the local press. Do check first to find out whether your presence will be welcome at these locations. A polite phone call requesting a short visit to do a little sketching or photography may prove successful.

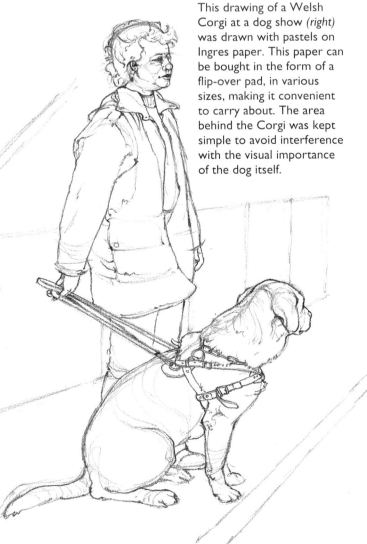

This drawing of a Welsh Corgi at a dog show *(right)* was drawn with pastels on Ingres paper. This paper can be bought in the form of a flip-over pad, in various sizes, making it convenient to carry about. The area behind the Corgi was kept simple to avoid interference with the visual importance of the dog itself.

1 This drawing of a dog being trained as a guidedog for a blind person was done with a 4B pencil on semi-rough cartridge paper. I chose the length of the person's head (A) as my measuring unit to check the accuracy of the proportions before adding any detail. To check the angles of the arm, harness and the body of the dog, I held my pencil vertically (B). Including the fence and pavement had the effect of anchoring the dog and handler in their setting, thereby preventing them floating off into space.

2 When I was happy that the basic outlines, angles and perspective were correct, I was able to erase unwanted marks and add in the detail.

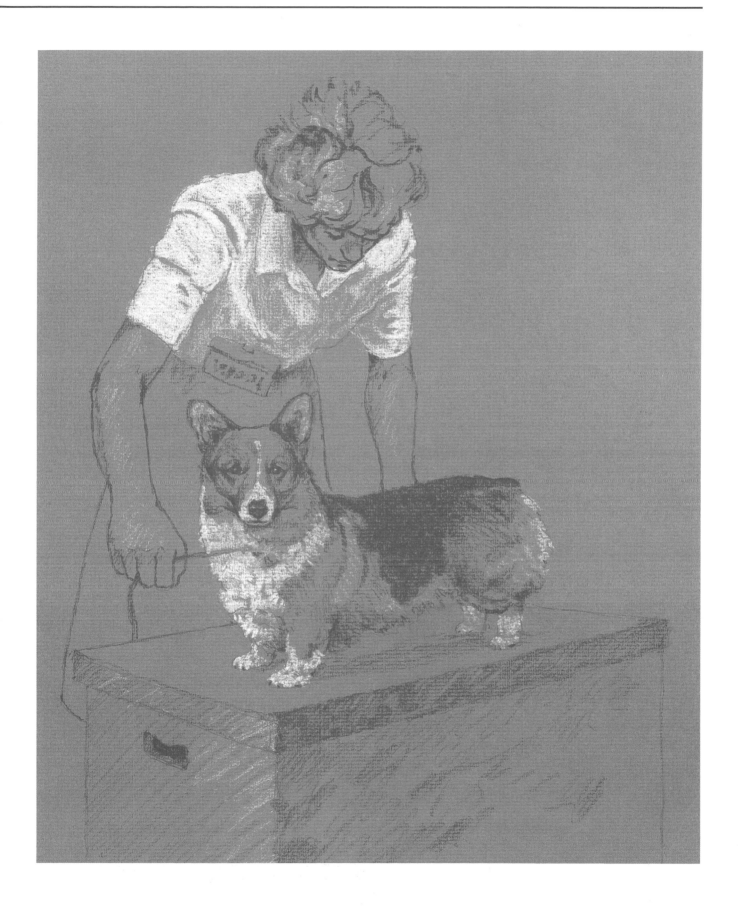

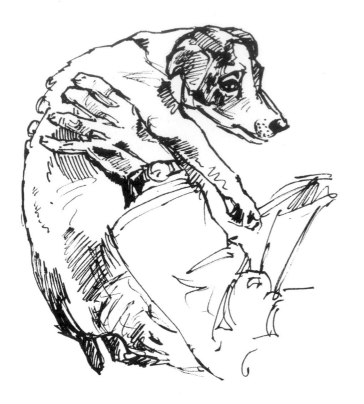

Other sources

Dog shows are another possible place to find your subject matter, and here there will be a huge variety of breeds to choose from. Another advantage of shows is that the dogs are required to stand still while on display, and so make good models. Dog races are another possibility, although here the only dogs will be greyhounds – often moving at impossibly high speeds!

If you are unable to get such direct access to your subject matter, you may have parkland or an area of waste ground near you where people frequently walk and exercise their dogs. You may also have friends or acquaintances who are dog owners. And if all else fails there are always the books in the local library, but do try to work from life if at all possible.

A quick pen-and-ink sketch was all that could be achieved when drawing this dog being held aloft *(above)*. Notice, though, how it perfectly conveys the heaviness of the animal's posture and the downward droop of its head.

Loose brush-pen marks were whisked across the paper to depict this dog running after a boy with a ball *(below)*. Observe how their shadows anchor them to the ground, and how just a single 'horizon line' behind them is enough to establish a setting.

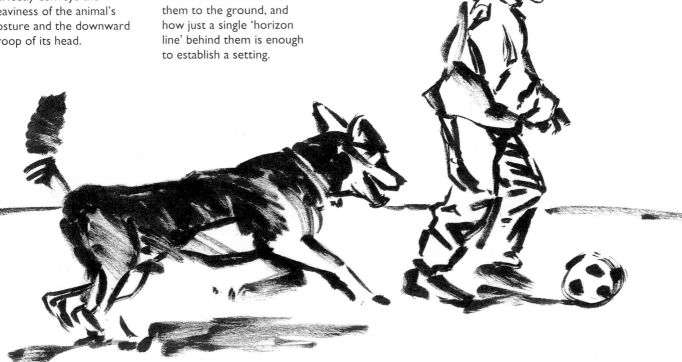

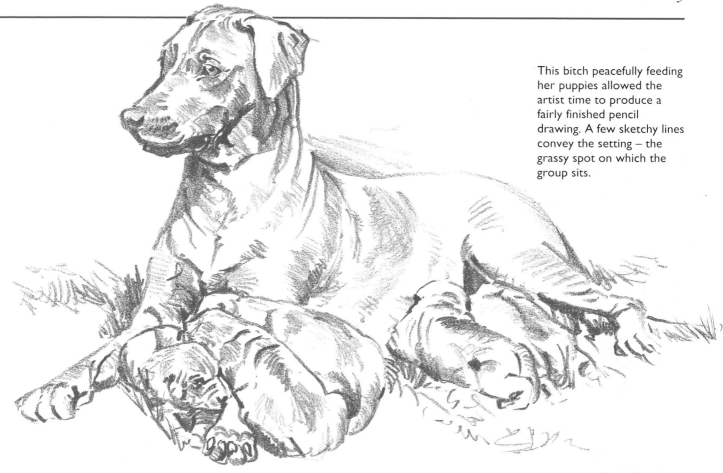

This bitch peacefully feeding her puppies allowed the artist time to produce a fairly finished pencil drawing. A few sketchy lines convey the setting – the grassy spot on which the group sits.

Moving models

Greyhounds tearing along the racetack move too fast for the naked eye to follow, but even with more placid subjects, movement is something you are going to have to contend with – the only time you can guarantee absolute stillness is when a dog is asleep. So don't be disappointed if your drawing isn't very finished. Try to establish the essentials in a good sketch. You can then build this up into a more complete drawing later. (Look, too, at the section on *Movement* on pages 46–51.)

Thinking about safety

When doing location work, always bear safety in mind. Listen to any advice given you as to where you should and should not go, for, apart from the possibility of an accident with the dogs themselves, there may be machinery or electrical apparatus in the vicinity which could be potentially dangerous.

Artist's Tip

It is good practice to take along some cover paper or tissue and adhesive tape when doing location work. Then, instead of having to use fixative, which can be ineffective in windy or even breezy conditions, you could cover your work with the paper, held in place on four sides with pieces of tape, to protect it until you can spray it.

Working from Photos

It is not always convenient, or indeed possible, to do drawings out in the open. There are also many situations which would be impossible to capture when drawing from life. This is when photography can be a really useful aid, whether you take the photographs yourself or use photographs from books or magazines. The advantage of taking your own is that you can choose the viewpoint you want and, to a limited extent, you can also choose the breed of dog you wish to draw. The plus side of using professionally taken photographs is the quality of the pictures and the variety of breeds they show, as well as all those exciting action shots.

Creating three-dimensional form

Always choose good-quality photographs with plenty of directional lighting whenever possible so that you can see exactly what is going on in the picture. Although photographs are relatively easy to copy, there is a danger that your drawing might end up looking flat. Try to 'read' the form within the image and use your existing knowledge of structure – and the references in your sketchbook – to construct a drawing with a real sense of three dimensions.

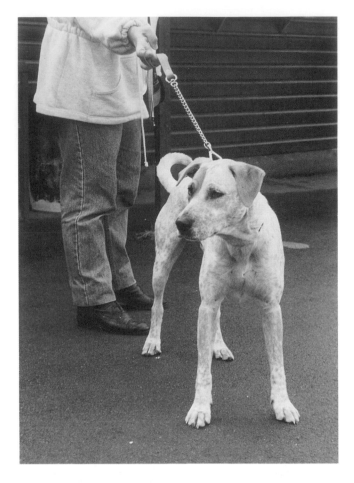

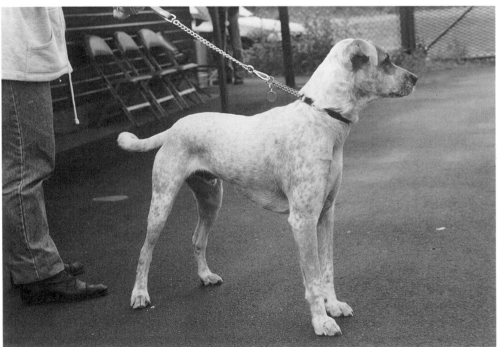

I combined these two photographs, showing the same dog from different viewpoints, as the basis for the drawing opposite. Photographs are helpful references in that they have already done some of the work for you. They have already translated three-dimensional forms into flat, two-dimensional shapes – and this is where they can cause problems. Take care that your drawings do not end up with the same flattened effect.

Altering the composition

You need not be a slave to what you see in the photograph. If a particular element is upsetting the composition – such as an individual object, or a highly decorative background which is overpowering and therefore distracting for the viewer – simply change it or remove it. For example, a photograph may show a dog lying on some very highly patterned cushions; in this case, it would be wise to replace the pattern with a simple wash.

Using videos

Videotapes can provide an exciting source of reference. If your recorder is able to play the tape in slow motion, or to stop to show a single frame, you will find it an invaluable tool for studying movement, something which is always difficult to observe with the naked eye.

By using my knowledge of structure and perspective, and varying the weight of line and amount of detail, I created a sense of depth and form not apparent in the original photographs.

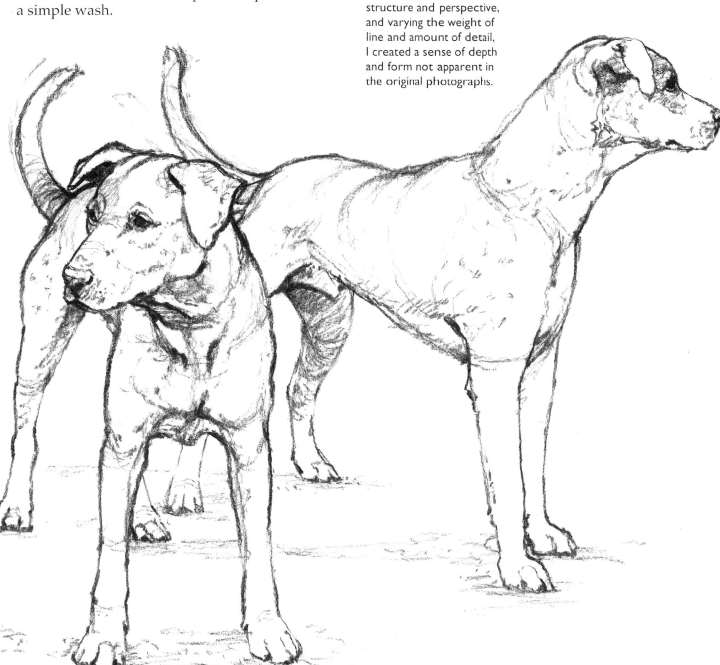

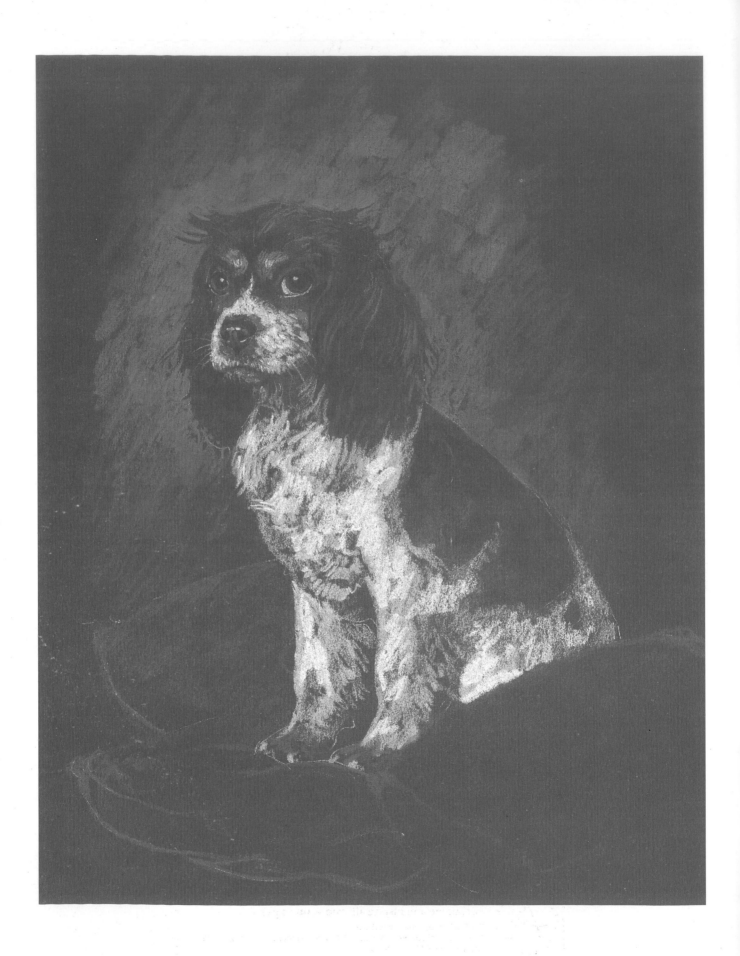